DYNAMIC
WATERCOLOURS

DYNAMIC WATERCOLOURS

Jane Betteridge

An exploration of colour, texture and technique

SEARCH PRESS

First published 2019

Search Press Limited
Wellwood, North Farm Road,
Tunbridge Wells, Kent TN2 3DR

Text copyright © Jane Betteridge, 2019

Photographs by Roddy Paine
Photographic Studios
Design copyright © Search Press Ltd. 2019

ISBN: 978 1 78221 557 8

Publisher's note

All the step-by-step photographs in this
book feature the author, Jane Betteridge,
demonstrating watercolour painting. No
models have been used.

Suppliers

If you have any difficulty obtaining any of
the materials and equipment mentioned in
this book, visit the Search Press website for
details of suppliers:
www.searchpress.com

You are invited to visit the author's website
at: www.janebetteridge.com

Printed in China through Asia Pacific Offset

Dedication

For Alan, Charlotte and Grace

Acknowledgements

Thanks to all the team at Search Press, especially Edd,
my editor, for all his help and guidance. Special thanks
also to my friends, family and students, who have always
supported and encouraged me over the years.

CONTENTS

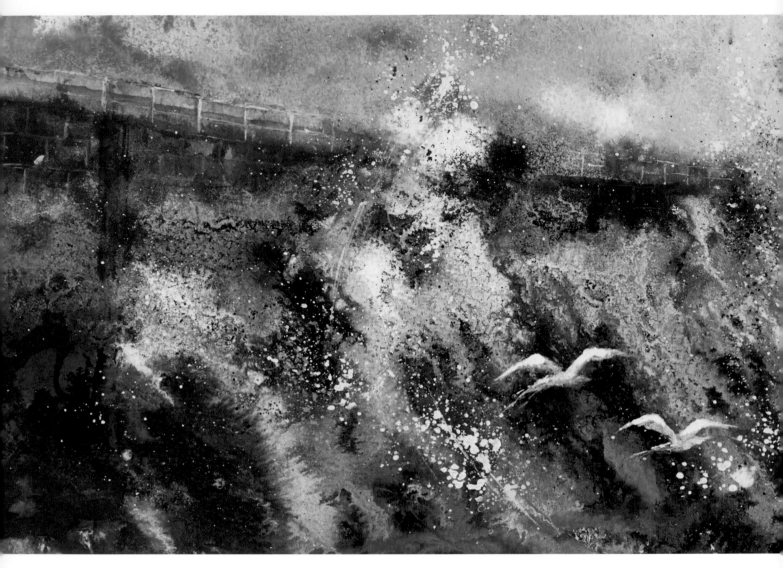

INTRODUCTION

'Dynamic' is a word often used without justification; an exaggeration, for example, of an event or achievement. However, when coupled with watercolour, dynamic describes exactly what your painting can be. This book shows how to achieve that dynamism in your work.

Throughout this book, my follow-up to *Watercolours Unleashed*, I aim to show you the unique properties of watercolour itself, and show you lots of things that you can do with it in order to make it even more interesting; often in a most unorthodox way. My no-nonsense, loose, free-flowing – call it what you will – style, using different techniques and additives, will inspire you and give you the know-how to produce work that you have only ever dreamt of. All of the secrets are here.

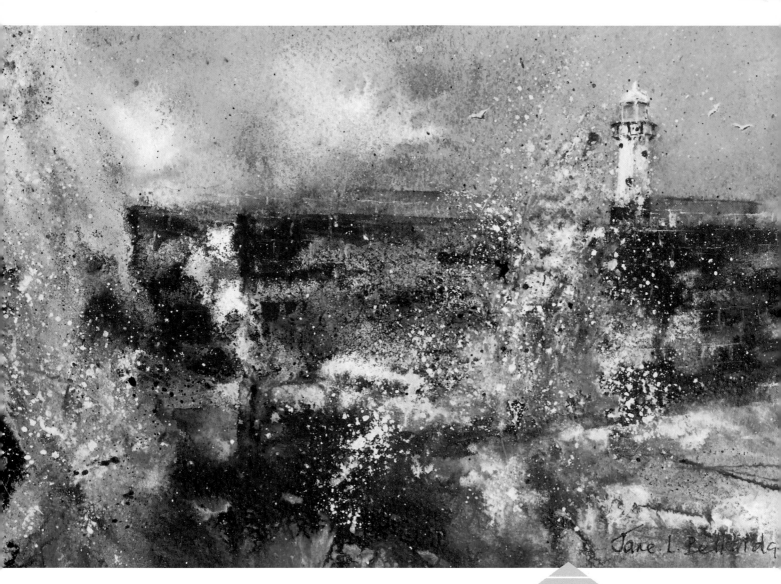

Jane L. Betteridge

Harbour Wall

The effects of combining watercolour with inks and granulation medium create the drama of the crashing waves in this atmospheric painting.

I feel it is most important, as an artist, to keep moving with your work. Don't get complacent, as complacency leads to stagnation: you will get bored and become uninterested and left behind and miss experimenting with all the wonderful things that can make your paintings so much more exciting.

Once you start 'playing', and enjoying yourself trying different things, you will be hooked, become more enthusiastic and find yourself in a different mindset. You will look at things in a different light and your thought process will change as you 'taste and savour' some of the new ideas I am going to show you.

Don't be shy. Watercolour, our chosen medium, is already wonderful; but if you can be a little more daring and throw caution to the wind, you will take your watercolour to more interesting levels a little at a time. It may take a little courage at first, but with the confidence you will gain from my guidance, you will find yourself surprised at how easy it is.

Once you have got rid of your inhibitions, and started experimenting, I know you will be hooked. My style may be alien to you, or perhaps you have never painted before. No matter. We will work through the book together, have fun and produce some great work. So, get ready, get set and let's go!

Jane . L. Betteridge

Silver Birch Copse

A dark blue wash over a pre-prepared cracked base gives depth and adds interest to this painting set deep in the dark woodland. The owl, added later with gouache, adds a finished touch.

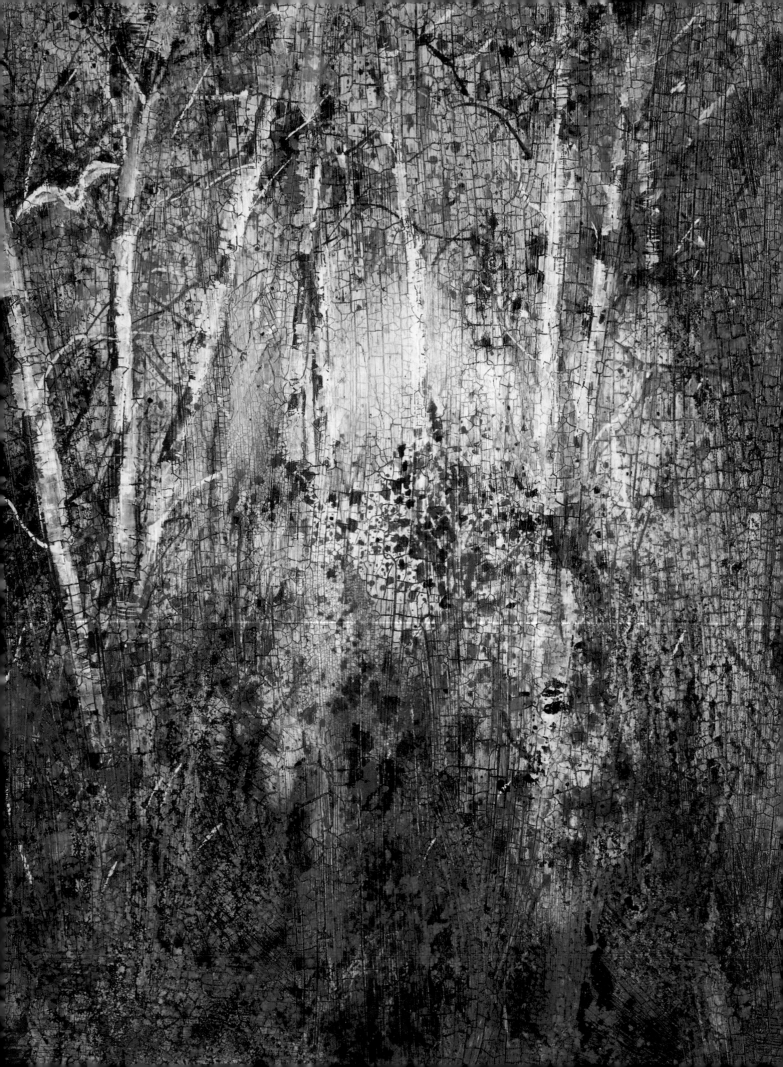

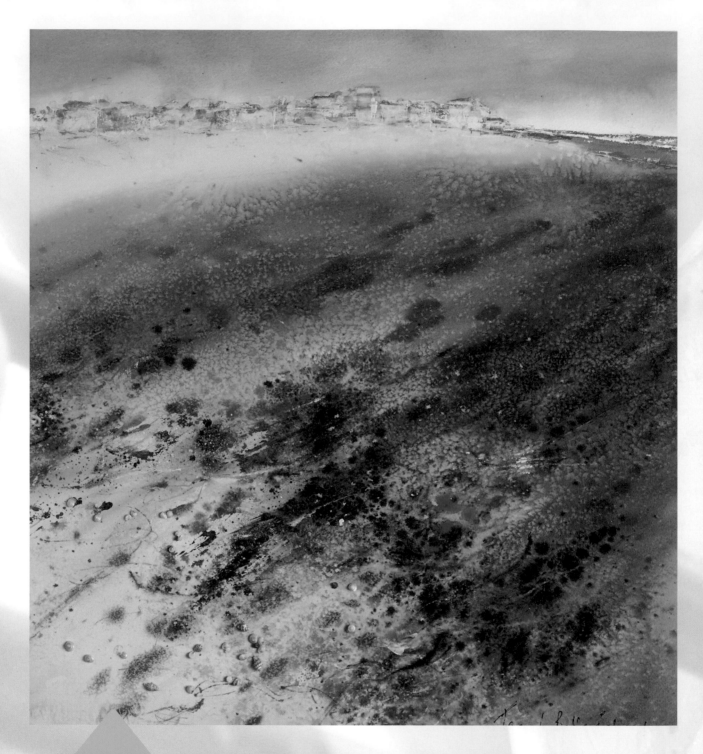

St Ives

The dramatic sweep of the bright turquoise sea is enhanced by using inks and collage to show the interesting patterns, textures and depth of the sea bed.

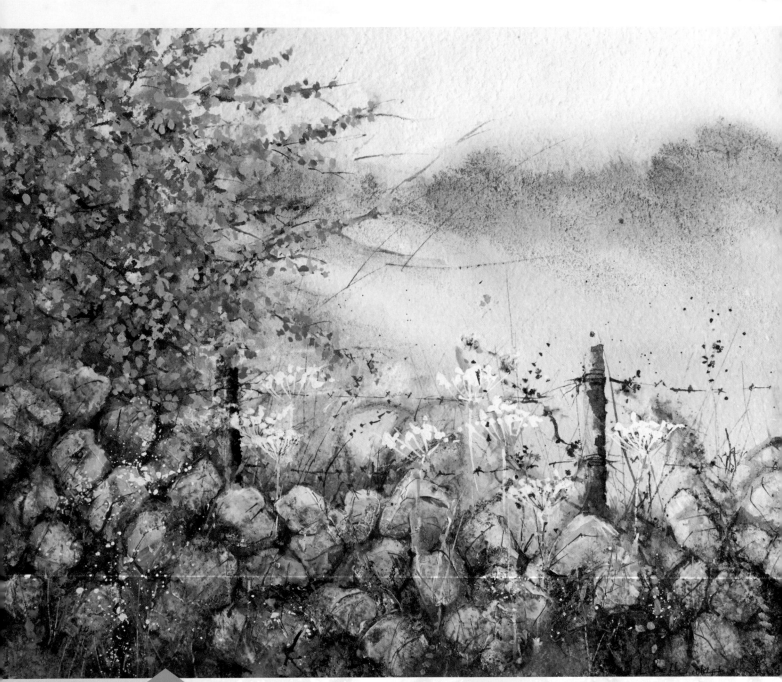

Blossom Tree

The simple granulating watercolour wash of the distant landscape adds a sense of perspective to the more pronounced and busy foreground, where gouache has been mixed with watercolour for the blossom and texture medium used to define the rocks.

PURE WATERCOLOUR

As a medium, watercolour is very exciting. In their purest form, watercolours are colourful, characterful pigments used with water as the only addition. However, this is just the first rung of the creative ladder. In this section, we start by exploring the fundamentals of pure watercolour in order to get you warmed up for the many different and exciting ways to use the medium later in the book.

Paint

Watercolours are available to buy from a number of manufacturers. Usually supplied in different sizes of tubes or pans, there is a difference in quality between the cheaper Students' quality paints and the more expensive Artists' ranges. Translucency and opacity vary across the wide spectrum of colour, along with granulation properties. Their pigments can be natural or completely man-made. Paint sticks and 'brusho' – very strong, powdered watercolour pigment in a pot – are also available to paint with.

My favourite colours come from various manufacturers, including ShinHan, the SAA, and Daniel Smith. I always use tubes because I prefer their immediacy – the dry paint in pans require more preparation.

Brushes

Man-made fibres, natural hair, or a mixture of the two, are used to make brushes specifically for watercolour painting. Watercolour brushes range in size from very fine, such as size 00 or smaller, through to very large wash brushes. The most common shapes are flat or round but where there is a need for specifically-shaped brushes – for more detailed or experimental work, or purely personal choice – other shapes such as riggers, filberts and angled brushes can be used.

My favourite brushes are made from a synthetic/sable mix for their springiness. I prefer to work with round brushes, from size 16 down to a small size 4. I also occasionally use a hake – a large, soft, flat brush that holds lots of water – for blending; a rigger brush for fine lines like tree branches; and an acrylic angle shader brush for lifting out details like stems and tree trunks.

Paper

Paper designed specifically for using with watercolour can be purchased from numerous manufacturers in pads, packs, rolls or loose sheets. Cotton rag moulded papers are the best surfaces to work on; these come in a variety of surface textures, weights and colours, which we will look at a little later on.

I usually use 640gsm (300lb) paper with a Not surface. This is thick enough not to require stretching, and the surface is suitable for most subjects and techniques that I use.

Pure Hellebore

Using just the materials and tools described opposite – a few paints, along with brushes and paper – you can create wonderful compositions like this. Some of the techniques, such as spattering, are looked at in more detail later on; but think of this 'pure' way of painting as just a starting point.

Preparing paint

If you have used watercolours before, you will be familiar with how to make paints workable. It is necessary to add water to the paint and mix with a brush until you achieve the correct consistency. I always advise that paint is mixed with water to the consistency of single cream.

Using tubes

If you are using tubes, simply squeeze a small amount of colour into a palette and gradually add water, (a pipette is ideal for this), using a brush, gradually incorporate the water into the paint until the desired consistency is achieved and required amount of paint mixed up.

Using pans

Pans of colour are not so readily prepared as they are a solid dry block and will take a little bit more time to work up. (I always spray my pan colours with water as I am setting up, to moisten them and hasten the mixing process). Use a wet brush to stroke the pan of colour, then transfer the pigment into a palette, carrying on repeating this to build up a well of colour.

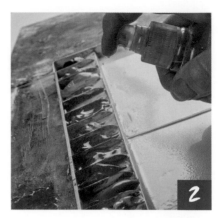
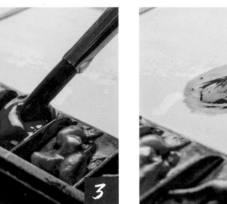

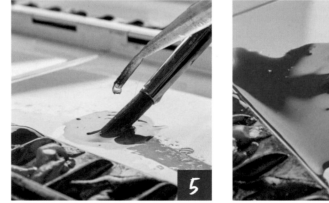

1 Squeeze paint from your tube into any palette wells that are empty.

2 Refresh the paint in your palette by using a water spray.

3 Fill a pipette with clean water.

4 Wet a brush and tap the excess off on the side of the water pot. Pick up a little paint on your brush.

5 Lift the paint over to a clean area of the palette.

6 While you make smooth, circular motions of the brush, use the pipette to add more water until the paint is a consistency similar to single cream.

Mixing colours

Colours can be mixed individually, together, or semi-mixed with one another, (this means mixing two or more colours separately and then allowing them to mingle and merge in the palette so that they are, more or less, half mixed together). It is best to use the brush to pull the separately mixed colours together in a loose way, this creates a much more unusual, irregular mix and will look more interesting on paper than one that has been mixed up fully.

Transparent colours are best for mixing together, especially if more than two colours are used. The introduction of a semi-opaque or opaque colour can deaden a mix, making it very dull and flat.

Paints can be applied to wet or dry paper. My favourite technique is to paint wet in wet, where paint is applied to wet paper and colours are allowed to mix and merge on the paper, creating new colours themselves. However, some colours are not compatible to one another, and, when merged together will create an undesirable hue. This is the case in opposites on the colour wheel – when complimentary colours meet it makes grey. It is always best to test colours on a scrap piece of paper before starting a new piece of work.

Changing tone

To lighten a colour, simply add water. I strongly advise against adding white paint to lighten as it will turn the paint into a milky, cloudy, colour which will go muddy when mixed with other colours.

Watercolours always dry lighter, so bear this in mind when mixing your paints, especially if working on wet paper as they will dilute slightly and, therefore, dry even lighter still.

1 Squeeze a little of your next colour directly into the palette, near to your prepared first colour.

2 Prepare the second colour in the same way as the first.

3 Draw the colours together into the space between them, then use circular motions to draw the two together in the centre.

4 Don't mix the two prepared paints together completely; leave some of the original colours clean. This allows you to use the pure colours later in your painting.

Which watercolour paper to use?

Whether you choose a paper with a rough surface; a smooth hot-pressed (or HP) paper; or a Not surface paper – short for 'not hot-pressed', and in between the two extremes – depends on personal preference and what kind of work you wish to do on it. Detailed work, such as pen and wash, is best suited to hot-pressed paper, for example, while textural subjects are more suited to a paper with a rougher surface.

In addition to having different surfaces, watercolour paper is also measured by weight, which describes the thickness. Any paper that is 300gsm (140lb) or less in weight needs to be stretched on a board to avoid it distorting and cockling. This is done by wetting the paper thoroughly, placing it on a flat board and sticking the edges down with brown parcel tape. Once dry, it will be an ideal surface to take paint: because it has been pre-stretched, it will be more resistant to cockling.

The heavier the paper, the less it will cockle, eliminating the need to stretch it. For this reason, you might choose a heavier weight of paper to begin with.

Most papers intended to be used with watercolour paints are white or slightly off-white, but very pale pastel shades of cream, blue, green and buff are also available from some suppliers.

All the different surfaces, weights and colours have their uses and experimenting will enable you to explore their particular properties to find whether they suit your style of painting.

Watercolour paper and mediums

You can, of course, paint directly onto watercolour paper as-is – that is what we are exploring here. However, applying certain mediums to the surface of the paper can create some very unusual and attractive effects. For example, a small amount of watercolour ground, brushed here and there over the paper surface with an old brush (leaving most of the paper untouched), and then left to dry, will make interesting markings when paint is added.

Skeleton leaves – manufactured craft type leaves available to buy from craft suppliers – and similar materials can be stuck on with a little collage adhesive and then covered in a watercolour ground and left to dry, to make lovely foliage effects when painted over in watercolour. We will look at these exciting opportunities in more detail later.

TIP

Handmade papers are also available to buy. These tend to have an interesting, uneven surface. Some are relatively cheap and light, while the more expensive ones are made from heavier cotton rag.

Applying paint to paper

Using a brush to apply watercolour to a surface is the most common method to get paint onto the paper. The larger the area to be covered in paint, the larger the brush you should use.

The easiest approach is to fully load the brush with prepared paint and apply it in even strokes onto the paper.

1 Wet the paper all over – paint will flow only within the wetted area. Any gaps you leave will end up with hard edges.

2 Load your brush with your paint – the brush will naturally hold a certain amount of paint. Take it to the wet paper and use smooth, soft strokes to apply the paint.

3 While the paper remains wet, you can apply more paint wet-in-wet. This will strengthen the tone.

4 Other colours can be worked into the wash while it remains wet; and they will blend and mix on the paper.

The flat wash

A basic flat wash is a good starting point to get to grips with the complexities of the medium. Load your brush and sweep it across the paper in a horizontal line, then reload the brush and add another line of paint which just touches the bottom of the previously painted line of colour. This is then repeated to however far down the page you want the colour to reach. It is better to do this with your painting board slightly tilted downwards. This helps to keep the paint even and fresh.

A wet-in-wet wash is exactly the same as a flat wash, except the paper is wetted beforehand. With this approach, the paints will bleed up and seep into one another for a softer finish. This allows you to create interesting backgrounds, like that in the painting overleaf.

It is important to prepare enough paint when laying a wash. If you run out and have to remix, the consistency may be different. If it is too watery, backruns occur and leave watermarks. You will soon get used to mixing and applying paint and as you get more experienced, it will become second nature.

Once paint has been applied to the paper, it is best left alone to dry; don't fiddle about with it. When painting a pure watercolour piece of work, it is meant to be fresh and clean looking, vibrant and uncontaminated, and this is the best way to achieve it.

A typical flat wash.

Painting pictures

After taking the basic steps of learning how to lay washes, you can then move on to a simple composition like that shown here. In order to do so, it is useful to bear some simple tips in mind, whatever you are painting:

• The main rule to remember – and you will no doubt find this out anyway once you start painting – is to paint from light to dark. This means that dark watercolour paint can be added over the top of light watercolour paint but not the other way round, as you can with oils or acrylics. As a result, highlights need to be preserved from any paint touching them.

• Once you have completed the first stages of applying paint to the paper, it is most important to make sure that the paper is completely dry before moving on to the next stage.

• You do not have to use a brush. Card, feathers, quills, twigs and other paraphernalia can all be used to make interesting marks. Watercolour, unlike oils or acrylics, is too fluid to apply with a palette knife – it will simply run off – but you can use palette knives to make marks in your paint.

• Similarly, painting does not have to be obsessively precise. Throughout the course of the book, I use the terminology 'dropping in'. This is how I describe placing a brush full of paint onto wet paper without using painterly strokes.

Preserving highlights

Masking fluid is a latex gum that can be applied with an old brush. Once dry, it will protect the painting surface from paint, which allows you to preserve your highlights. Once you have finished the painting and it has dried, you simply rub the masking fluid away to reveal the clean white paper beneath.

Painting *Buddleia & Bindweed*

Once you practise a few basic steps, you will find a way of applying paint that you like the look of best. For example, wet-in-wet is my favourite method of working as I love to watch the colours run and amalgamate on the paper, creating other colours and effects that could never be achieved by any other method.

For this pure watercolour painting, I masked out the white bindweed and buddleia with masking fluid before painting the background with a wet-in-wet watercolour wash. Once dry, I painted in the buddleia. When completely dry, I removed the masking fluid and painted in the centres of the bindweed.

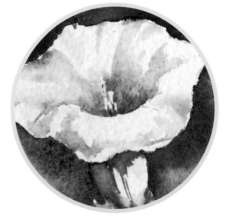

Bindweed

The white was preserved with masking fluid, and the shadows were added near the end of the painting process.

Soft background

Working wet in wet creates wonderfully soft results.

Buddleia

The use of masking fluid left small areas of clean paper; perfect to suggest the texture of buddleia.

Buddleia & Bindweed
Painted on a heavy 640gsm (300lb) Not surface watercolour paper.

Painting *Poppies in Summer*

A photograph taken in my garden inspired me to try to produce a painting that reflected the colours, textures and sheer beauty of these plants. I really loved the colour combination of the bright red poppy flowers against the pale green seed pods, plus the vibrant purple of the lupins.

I tested a few paint colours first on a scrap piece of paper to make sure that they would work well together and found that the ideal combination was pyrrol scarlet (a vibrant bright red from Daniel Smith), leaf green, bright violet, and ultramarine deep from ShinHan. The latter three are colours I use a great deal in my work.

Using a quarter sheet of Saunders Waterford, high white 640gsm (300lb) Not surface paper, I sketched a simple drawing of just two seedheads, making sure that they were slightly to the right-hand side – placing your focal point away from the very middle of the paper is a quick way to make a more striking composition.

The seedheads needed to be masked out with masking fluid (see page 18) so that I could freely lay a wet-in-wet wash over the background area. As the masking fluid dried, I prepared my paints individually to the consistency of single cream, making sure I had plenty and wouldn't need to stop and remix more paint when in the middle of laying the wash. When the masking fluid was dry, I wet the paper all over. Using a size 12 round brush I then dropped in pyrrol scarlet around the seedheads, and the leaf green here and there with a touch of the ultramarine added; then did the same with the bright violet, aiming to suggest some lupin shapes in the background wash. (Note that the main lupin was added later.) A mixture of the pyrrol scarlet and ultramarine deep was used to suggest the centre of the poppies. Once all the colours were added, I blended the wet paint out towards the edges of the paper using a large hake brush. Because I had wetted to the very edges of the paper, the paint blended really well and didn't leave any hard lines. It was then left to dry.

The next stage was to remove the masking fluid and, using a size 8 round brush, I painted in the seedheads using a mix of leaf green with a touch of ultramarine deep to add touches to the shadow side of the seedheads and stems. The lupin was then painted using the bright violet, again with touches of ultramarine deep added. To finish, I added some paint to a skeleton leaf and stamped them onto the paper (see pages 68–69) before wetting the marks here and there to make them less contrived. On some of them, I added a touch of the violet to help tie the painting together.

'Once all the colours were added, I blended the wet paint out towards the edges of the paper.'

Poppies in Summer

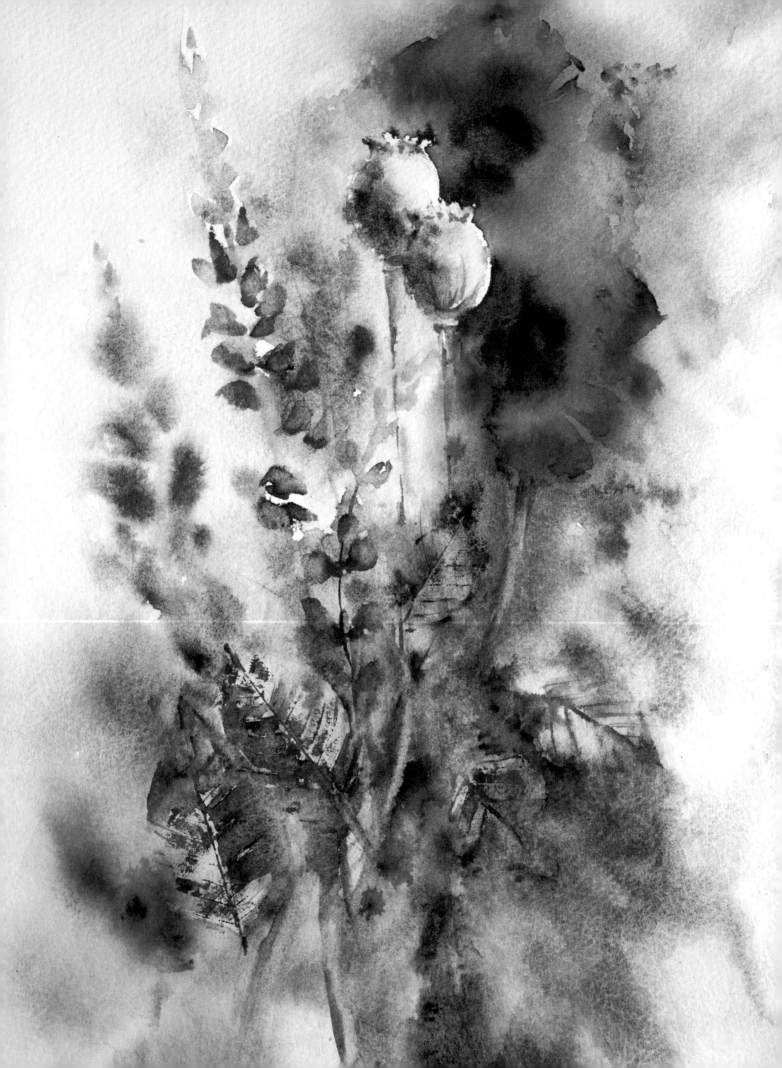

PREPARING

One of the ways in which I work is to prepare the painting surface beforehand, ready to take the paint. This section of the book explores the ways in which to experiment and use technical mediums to create a surface to work upon. I want you to move forward and change your thought process from thinking that all your work has to be painted on paper – it doesn't, not even with our favourite type of paint, watercolour!

Different surfaces suit different subject matters, so it is important to think about this when planning your painting. The surface you decide to use – or create – can have a huge impact on your work, by making the paint behave differently from when it is applied to a simple piece of watercolour paper.

To build a surface on which to work, mediums can be added to different bases. These interact with the paint to make it create unusual, invigorating, interesting effects. The mediums range from commercially sourced surface products manufactured especially for the job – watercolour grounds, crackle pastes, texture mediums and modelling pastes – to additions and elements like metallic leaf and gilding flakes. Different papers, such as tissue or collage, are further options; as are modifying the existing surface through techniques like scratching marks into the paper. All of the techniques here are designed to help to take your work up a few more rungs of the creative ladder and make you eager for more.

THE SURFACE

SURFACES

Watercolour grounds have been quite a revelation for me, and have taken my work forward to another level. They are a manufactured primer medium that allows artists to use watercolours on otherwise unpaintable surfaces. Canvases and boards are normally meant for the use of oils or acrylics and are primed accordingly with gesso, but when re-primed with this medium, you can paint on them using watercolours. Other surfaces, including plastic, wood, metal, ceramics – even leather – can be primed and painted on using watercolour with this primer. It really is so versatile.

It is available to buy in large and small plastic bottles and tubs. I favour the white and transparent ground but the medium is also available in black, buff and gold.

Without the preliminary preparation of applying the ground, watercolour paint will simply run off some surfaces. For this reason, aim to cover the surface completely with the ground, unless the surface you are preparing on is already suitable for watercolours (watercolour paper, for example).

Priming with transparent watercolour ground

Transparent watercolour ground is best applied with an acrylic brush – these are stronger than watercolour brushes, which can be damaged by the medium – and 'feathered' out to the edges to a smooth finish by using very light strokes. This feathering technique takes a little time but is well worth the effort, as the result is a really smooth finish, free from lines and brush marks.

1 Simply pour out a small amount of the ground onto your surface, then begin to smooth it out with light strokes of an old brush.

2 Continue feathering out the surface, then leave to dry. It will dry clear, allowing whatever is beneath to show through.

Mackerel on a Map

Because this ground is colourless, it is ideal for using on top of printed papers, allowing their pattern to show through when watercolours are painted over it, as shown strikingly here.

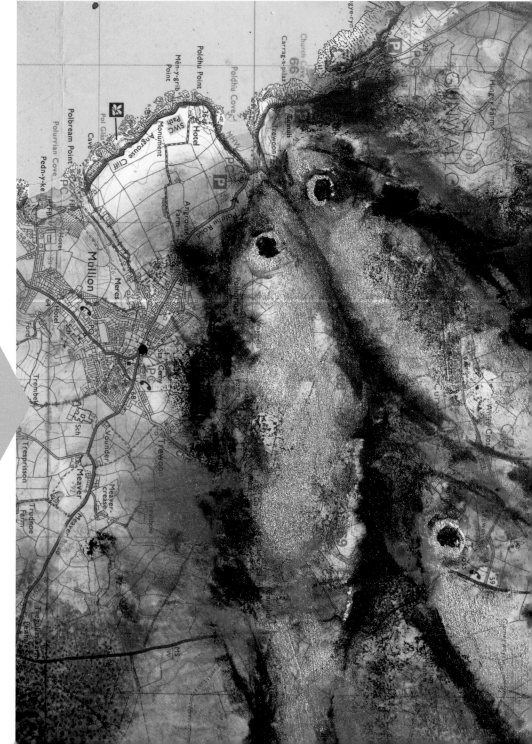

Painting on printed paper

Pre-printed papers can act as a fantastic base for your painting. To prepare the paper for watercolour, adhere it to a piece of mount card using spray mount glue, then cover it with transparent watercolour ground to make sure that the paint does not bleed into the printed paper. In concert with being stuck down to mount card, the watercolour ground helps to stop the paper from cockling too.

A selection of printed papers.

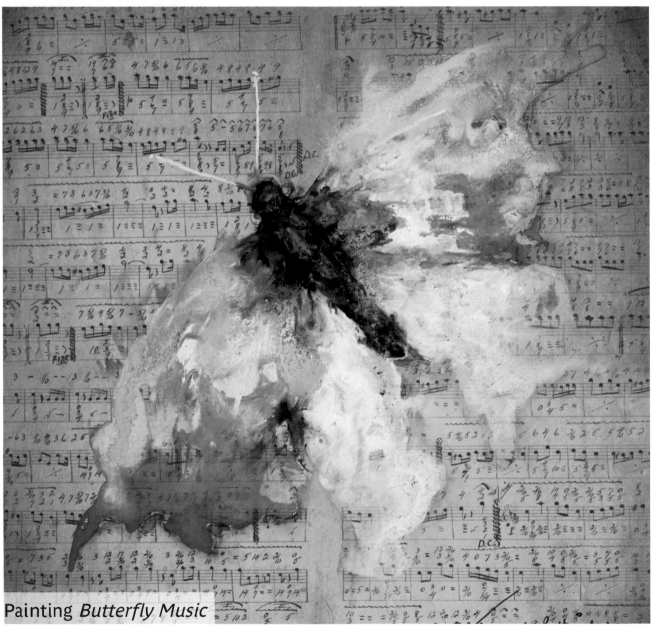

Painting *Butterfly Music*

I tried to portray the fluidity of this lovely orange-tipped butterfly by letting the paint and ink that I used flow away from the main body of the insect to give it movement. It is painted on commercially-bought printed paper (available from craft shops) – the musical design worked well with the butterfly image.

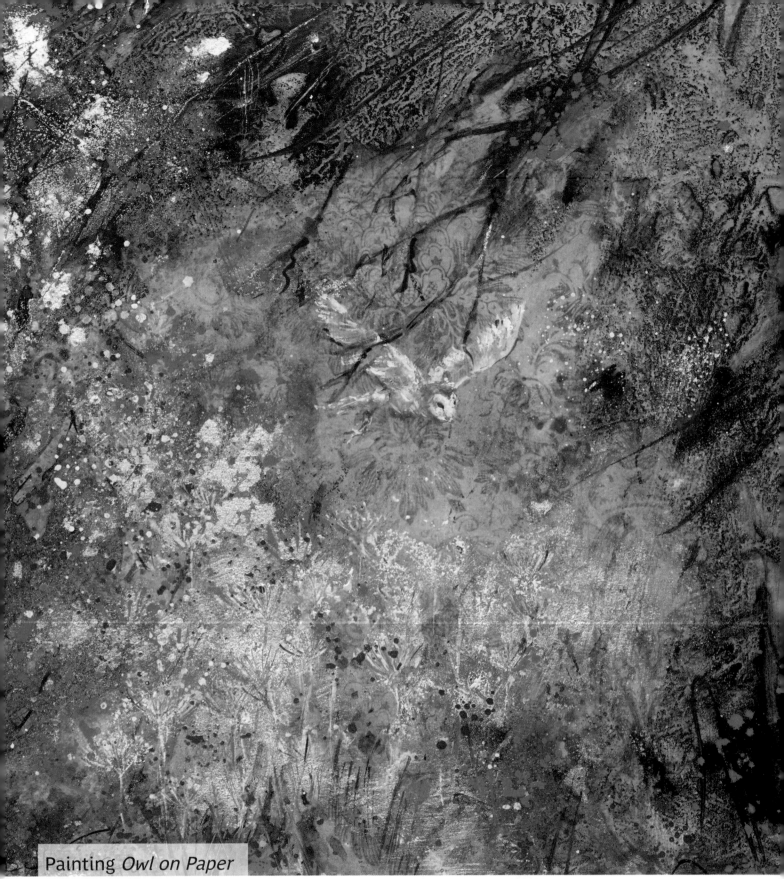

Painting *Owl on Paper*

Using spray mount, I secured a commercial piece of printed paper to a piece of mount card, smoothing it out to eliminate any creases or air bubbles. I then applied a coat of transparent watercolour ground using the feathering method so that hardly any brush marks remained. When this was dry I used watercolours, inks and gouache to paint this woodland scene over it, allowing some of the lovely patterned paper to show through.

I didn't need to protect this with the watercolour fixative when it was completed, as it was being framed behind glass.

A selection of canvases.

Painting on canvas

Watercolour is not compatible with the gesso primer used to prepare most canvases for oils or acrylics, but watercolour ground applied over the gesso makes this exciting surface available for the watercolourist.

Chunky canvases are really popular as they are ready to hang as soon as the paint has dried – there's no need to frame them, though you can if you wish. Not as rigid as boards, canvas can be quite springy and flexible to work upon. This can be controlled with the little pegs that are supplied with most box canvases, but the movement and flexibility can help to add still more dynamism and excitement to your painting.

Painting *Ink & Flowers*

I used acrylic inks and granulation medium alongside my watercolours for this canvas painting, allowing the painting media to run and merge together and create a lovely background effect on the chunky canvas surface.

When this was dry, I added some hydrangea petals, secured to the canvas with PVA glue, then covered everything in transparent watercolour ground and left to dry overnight. I then used two of my favourite watercolours, verditer blue and lilac, and painted on top. I added a little gold bronzing powder too. Once dry, I protected the surface with a watercolour fixative spray.

The acrylic ink and granulation effect remains visible through the transparent ground, all adding to an interesting, unorthodox piece of work.

The use of transparent watercolour ground allowed me to paint directly over the hydrangea petals secured to the surface. Note that the ground has been applied so thinly that even the delicate detail of the flower's structure remains visible – a wonderful contrast with the coarse grain of the canvas.

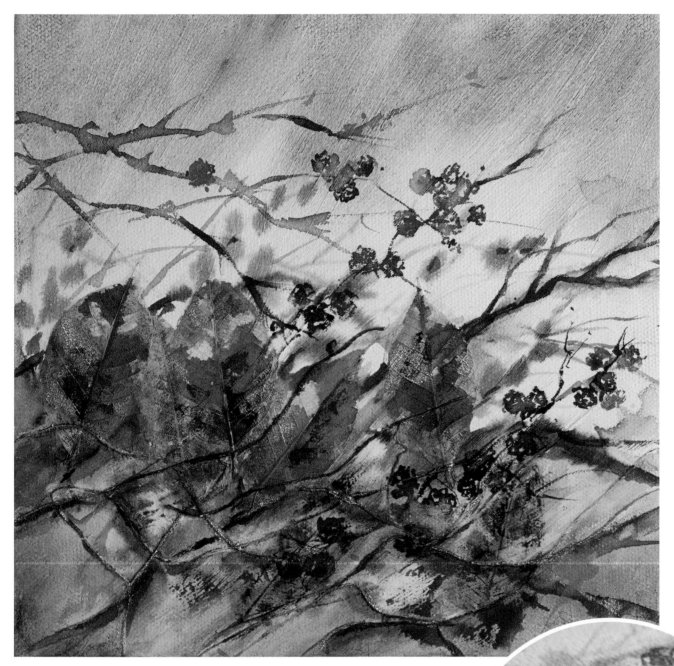

Painting *Golden Hedgerow*

In this piece of work, skeleton leaves and thick cotton thread were stuck down with PVA glue onto a chunky canvas, before I used an old brush to cover it all over with the fine watercolour ground. This not only primed the canvas, but primed the texture-making materials as well. When this was completely dry, I added paint, inks and a little gold bronzing powder, letting some of the paint flow around the leaves and thread and carried on painting as I would normally. This wouldn't have been possible without the use of the ground. I protected the painting with a watercolour fixative.

Canvas board.

Painting on board

Canvas-covered boards have a similar texture to traditional canvases, but they are more rigid, and very cheap to buy. I like to work on boards and canvases for a change, especially blocky, chunky canvases as they don't need framing. Before starting to paint, you will need to prime the surface of the board with a fine watercolour ground to make the surface suitable for using watercolour paints.

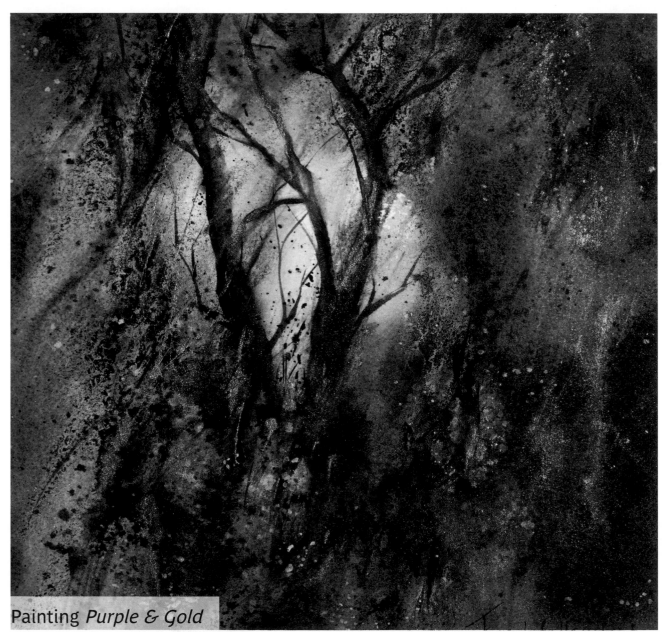

Painting *Purple & Gold*

This woodland painting was done on a board. I used paints, inks, granulation medium and gold bronzing powder. We cover how to combine all of these materials later on in the book.

Painting *Peaceful View*

I primed a canvas board with white, smooth, watercolour ground. Wanting
a soft finish to this piece of work, I used a large acrylic brush to apply the
medium and feathered it out to the edges to a smooth finish by using very
light strokes.

When the prepared board was completely dry, I began to paint as
I normally would when working on paper. Because this painting will not be
framed behind glass, I protected it with a watercolour fixative spray.

Marks or not?

The feathering method will help to
leave a smooth surface as shown here.
However, brush marks and palette
knife marks can be used deliberately
to suggest trees, clouds, foliage and
horizon lines if you want to leave more
noticeable marks in the medium.

TEXTURED GROUNDS

In addition to being available in different colours, watercolour ground mediums are available to buy in two different surface textures – coarse and fine – which we are looking at here. These grounds are similar to the transparent ground shown earlier, and will allow you to paint on different surfaces. The main difference is the gritty texture that they create, which works beautifully with watercolour paints.

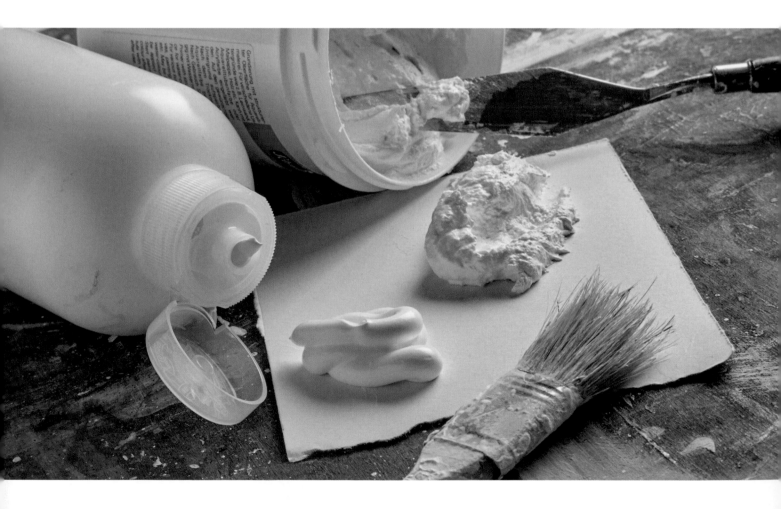

Priming with coarse ground

With a slightly gritty texture, this is best applied with a palette knife. I am using it here to prepare a piece of mount board. Both coarse and fine watercolour grounds need some time to dry – if possible, leave them overnight before beginning to paint on them.

1 Use a palette knife to scoop a generous amount of the ground from the pot and begin to smear it on the surface.

2 Using long, sweeping movements, you can create a relatively even but textural surface.

3 Alternatively, you can create ridges, recesses and marks in the surface using the edge and blade of the knife to create much more striking textures.

Priming with fine ground

Being slightly more fluid than the coarse ground, I find that the finer ground is best applied with a brush. It is still slightly textured, so use an old household brush, rather than one of your painting brushes.

1 Squeeze a generous amount of the ground directly onto the surface.

2 Use the brush to feather out the fine ground to get a fairly smooth finish. You may wish to wear gloves, as it can be a little messy – and if you do, you can even use your hands to smooth the surface.

Textured ground, ready to paint upon.

Painting on texture

Painting on a textured surface takes some getting used to. It is so different from a smooth surface because of all the raised textural marks. Paint reacts differently when flowing over the surface, and it bleeds into the markings and cracks. Textured grounds are not suitable for subjects such as botanical works, where very precise marks are needed, but are ideal for other areas of painting, where texture effects are required or if, like me, you just like the effect of how paint reacts with this sort of surface.

Normal watercolour brushes can be used but the surface will wear them out more quickly than on paper or other smooth surfaces, so I recommend against using expensive sable brushes here.

Other painting media such as inks and collage, and materials like masking fluid, can also be used on textured ground in the same way as you would use them on any other surface.

Painting *Surf's High*

This painting, of rough seas, was painted on a canvas board primed with coarse watercolour ground for extra texture. I laid in a background watercolour wash, wet in wet, using ultramarine blue and transparent umber for the sky and distant land. Whilst mixing the colours in the palette, I added granulation medium (see page 88) to the paint. This gave me the subtle, soft effect I wanted to create, and increased the interaction between the paint and the textured surface.

I intensified the colour at the bottom and dropped in some cotton thread, quite thick pale blue paint, some sepia ink and then dribbled in the granulation medium. I waited until it was completely dry before removing the thread and then added a bit of bright orange spattering.

Granulation

The graininess caused by granulation medium helps to highlight the texture of the coarse ground.

Seagulls

If the painting lends itself to something appearing differently from life, don't be afraid to change it. Here my seagulls are blue, not white, as I thought that was what the painting needed.

Spattering

This expressive technique, detailed on page 84, works well with heavy texture to describe sea spray.

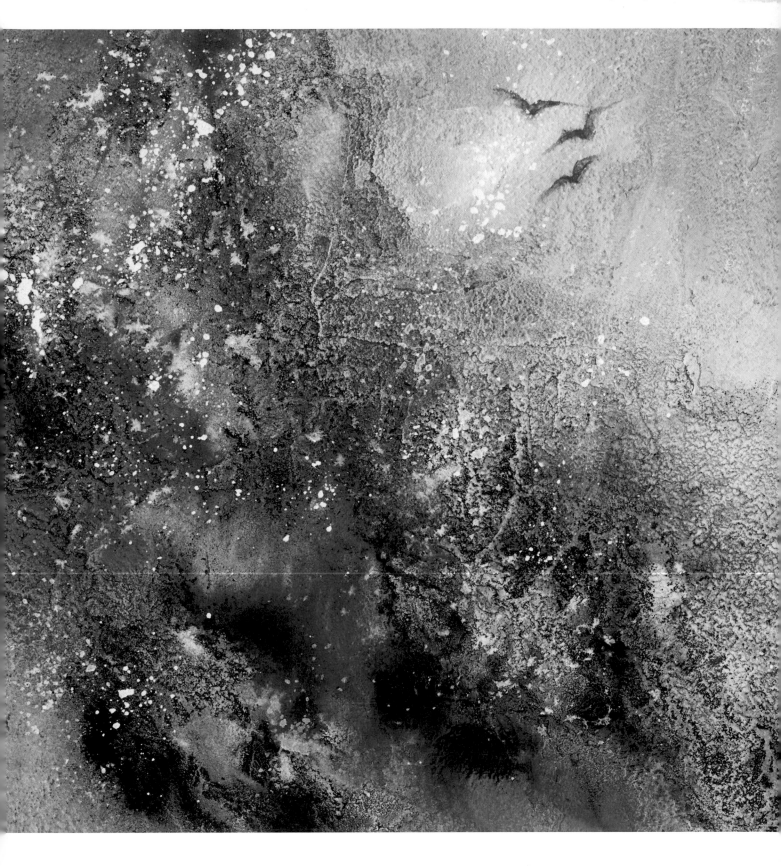

CRACKLE PASTE

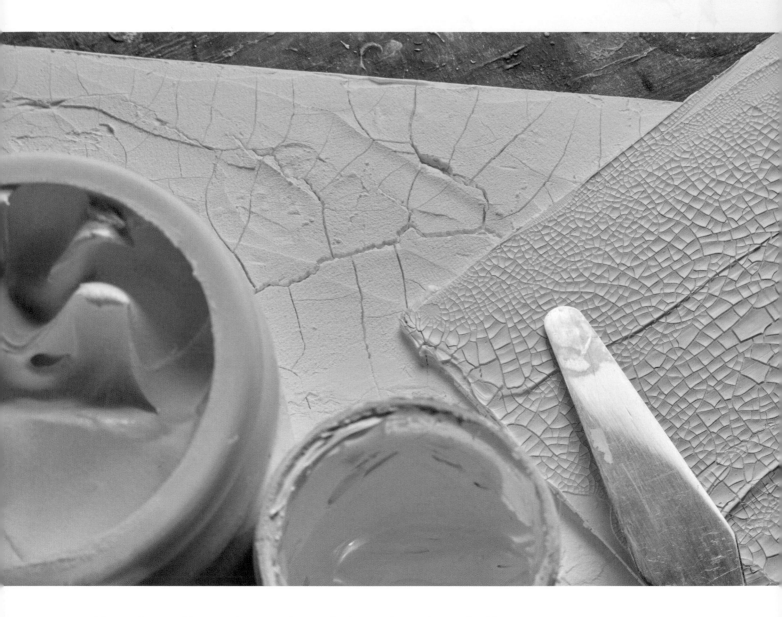

I love using crackle paste in my work to make it more interesting and add a different feel to the result. When it first came on to the market, it was intended to be used to make artwork – or objects from other crafts – look old and aged, but I think it's a great addition to your stash of artistic materials. Use it when you want to add interesting textures to work on.

There are several different types of crackle gel available from different manufacturers. Some require a two-stage process, but my favourites are the simpler types, which just require time to air dry.

I use Golden Gel Acrylic Medium as crackle paste when I want large, more noticeable, cracks to appear on my painting surface; and a white DecoArt crackle paste or their white crackle paint when I want a more subtle, eggshell type of effect.

Preparing a board with crackle paste

This medium must be painted onto a non-absorbent surface to make it work. Crackle paste is best applied to acrylic boards and canvases as they are usually bought pre-primed with gesso (a primer that prepares surfaces for acrylic and oil paints and makes the surface non-absorbent). As a result, these surfaces will take the medium easily. You can use crackle medium with mount card or watercolour paper, though these must be primed with gesso and allowed to dry before you add the crackle paste.

When dry, some crackle paste mediums need to be thinly covered in a watercolour ground (either white or transparent), to enable the watercolour paints to stick to this unusual, interesting surface.

1 Scoop a generous amount of the crackle paste onto the back of your palette knife.

2 Smooth it onto the surface. It is self-levelling, so don't worry about getting the surface completely flat.

3 The thickness of the paste will determine the size of the cracks. The thicker the paste is applied, the larger the resulting cracks.

Allow the surface to dry completely.

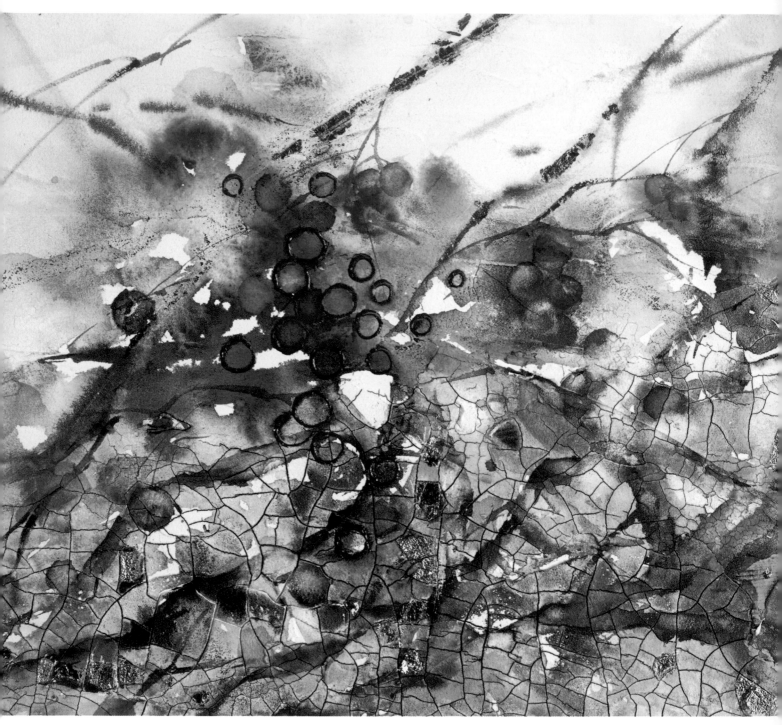

Painting *Patterns of Nature*

For this painting, I decided to use crackle paste on the lower half to add interest, but wanted a sense of softness in the top half for more detail. To achieve this, I prepared a piece of mount card with crackle paste at the bottom and fine watercolour ground at the top – the two are compatible, so you can work them into one another at the join between areas. Once dry, I used reds, blues and gold watercolours to paint over the surface, and added some sepia ink and gold metal leaf.

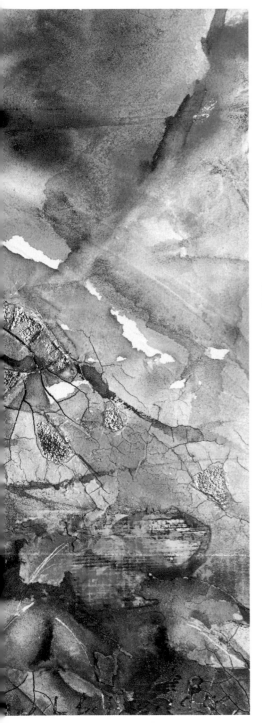

Using crackle paste in your paintings

Using a palette knife will help you to achieve the best results. Once spread over your painting surface, you just need to wait for the effect to develop. Generally speaking, the more thickly it is applied, the longer it will take to dry ready for painting.

The details below show some different techniques that work well with the craquelure effect that results.

Crack size

The size of the cracks is determined by how thickly you apply the crackle paste: a relatively thick application resulted in the large cracks here.

Contour gel

To add interest, I drew red circles using contour gel to represent berries.

Gold leaf

The shapes that the crackle paste creates can be picked out individually. Here, I have used gold leaf to pick out parts of the cracked surface.

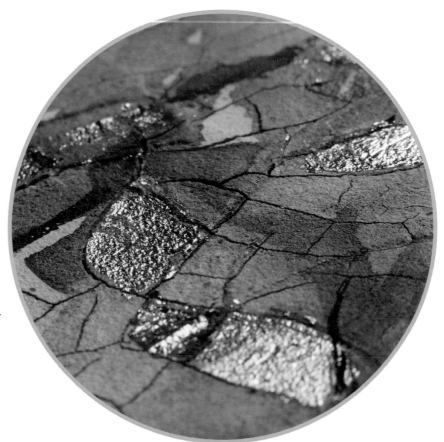

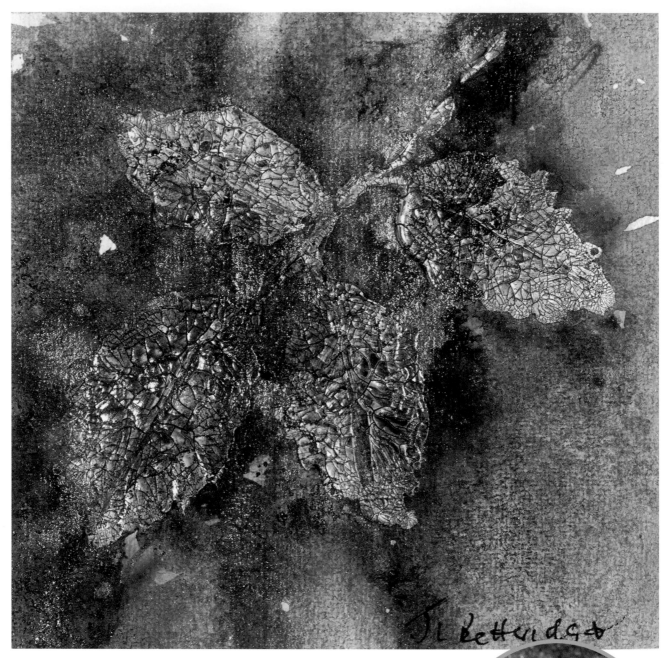

Painting *Textured Leaf*

These autumn leaves are painted on a handmade khadi paper surface. For reasons unknown to me, the crackle paste seems to work really well on this surface, needing no preliminary preparation. The thin paper cockles slightly as the medium dries, but that only adds to its charm.

For this painting, I sketched a few simple leaves and then painted over them with the eggshell crackle paste, leaving the remaining paper as it was. After a few hours, the lovely crackled effect had developed. I used some warm autumnal watercolours to paint over the whole of the painting, then added some gold bronzing powder to the leaf area to enhance the overall effect.

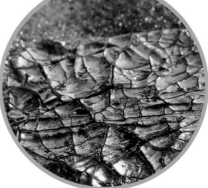

The fine eggshell crackle effect evokes the texture of a fallen leaf.

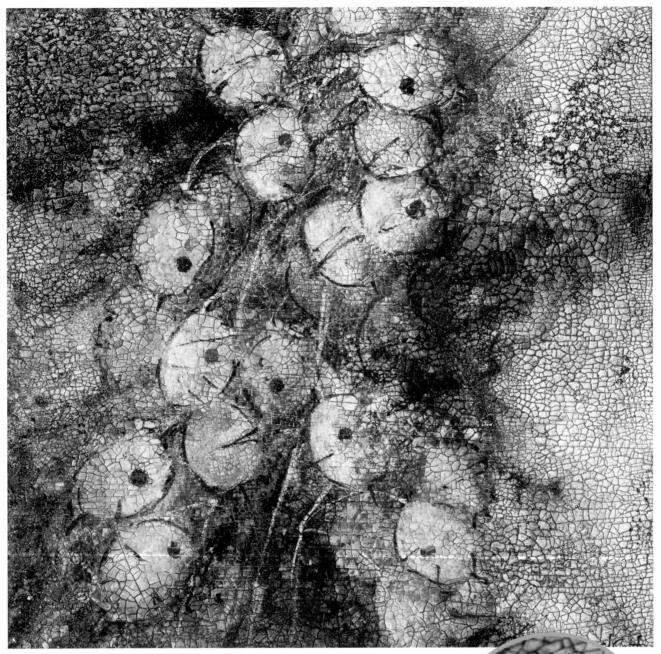

Painting *Honesty*

For this painting of honesty seed heads, one of my favourite subjects, I used very thin khadi watercolour paper again. After completely covering the whole of the paper in the crackle paste, I left it to work its magic overnight. Once dry, I used Nordic blue watercolour and sepia ink to create the background, then painted in the seed heads using white acrylic ink. I added a little detail with the sepia ink.

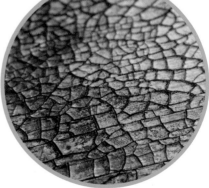

Ink flows well into the cracks, further emphasizing the textural effect of the crackle paste.

MODELLING PASTES

Modelling pastes are similar to watercolour grounds, but thicker, which allows them to be shaped and built up for striking textural effects. My preferred range of these mediums is Schmincke's aqua modelling pastes which, as the name suggests, is designed especially for the watercolour artist. Once dry, these mediums are water-resistant (so they won't wash off), but will hold watercolour.

These pastes come in small and medium sized tubs, are opaque white and are available in two finishes: fine, which is smooth; and coarse, which has a wonderful graininess, similar to a textured ground.

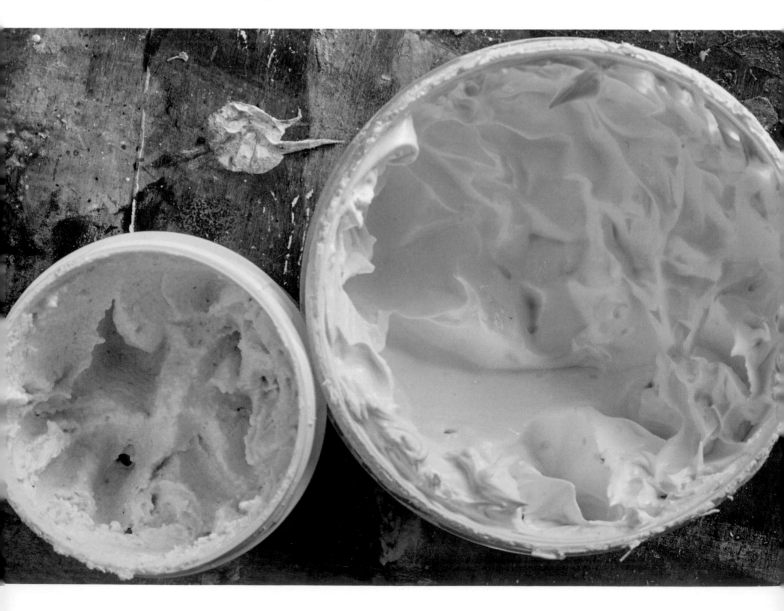

Preparing a surface with modelling pastes

Both coarse and fine modelling pastes can be applied to any surface in order to give a highly textured base on which to paint over. As with coarse texture gel, a palette knife is more suitable than a brush for applying these mediums, because of their consistency. Modelling pastes must be left to dry completely before painting upon them.

Coarse modelling paste

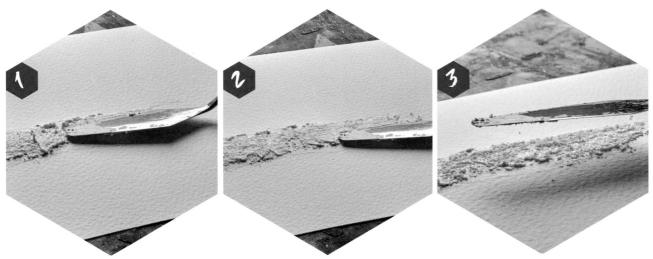

1 Use a palette knife to apply the coarse modelling paste roughly where you want it.

2 Drawing the flat of the knife over the paste will allow you to create flatter areas, though it can be built up to a depth of 1cm (½in) at a time if you wish.

3 Once it is on the surface, you can 'pat' the modelling paste with the flat of the palette knife to create a slightly rougher texture.

Fine modelling paste

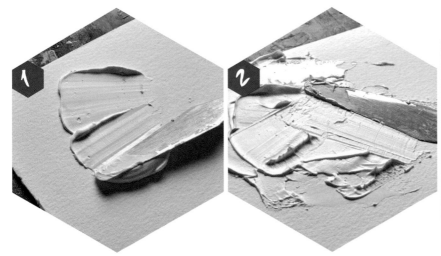

1 Use a palette knife to apply the smooth modelling paste to the surface.

2 Chop and change the angles of the knife to create rocky textures. The medium will hold its shape as it dries.

3 As with coarse modelling paste (see above), you can pat fine modelling paste to create interesting textures.

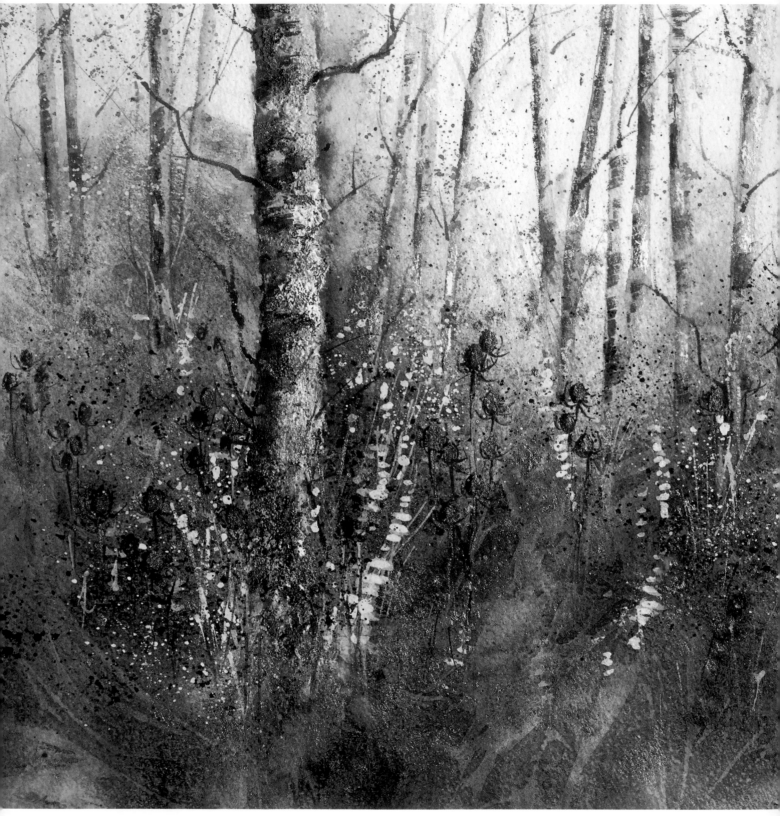

Painting *Teasel Wood*

Teasel Wood was painted on watercolour paper in a fairly conventional way, with the exception of the main focal point – the silver birch. I wanted this to really stand out, so I applied coarse modelling paste to the trunk and allowed it to dry fully before I started applying any paint. The result is a very three-dimensional effect that gives this important part of the composition more prominence within the painting.

Using modelling paste in your paintings

Modelling paste works well with watercolour paper; providing a lovely contrast in texture between the paper surface and rougher, grittier paste. This enables you to build up specific shapes, such as trees, in order to draw more attention to particular parts of your composition.

Blending paste

This detail shows the modelling paste in place prior to paint. Since I wanted the tree to fade into the undergrowth, I was careful not to finish the base in an abrupt, straight line.

Painted paste

Here you can see how the paint interacts with the coarse modelling paste to give a striking, highly textured finish.

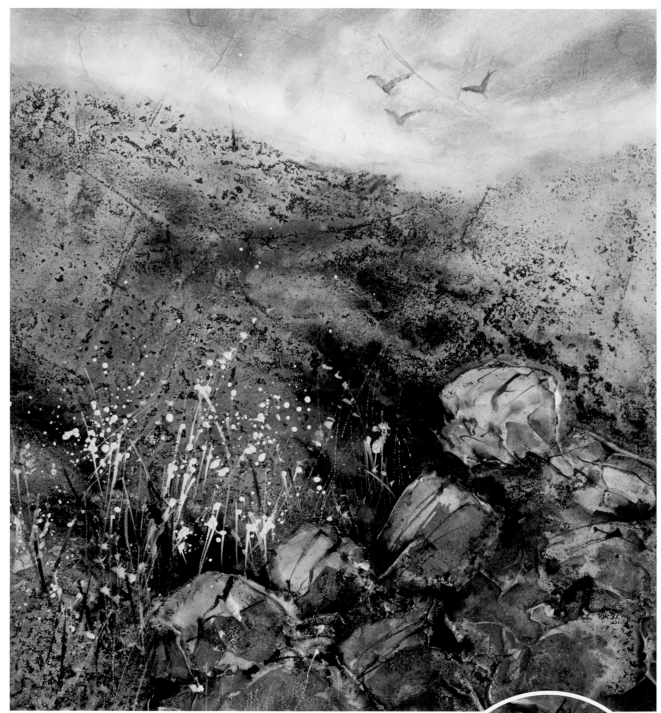

Painting *Moorside*

This painting was an experiment in using the fine modelling paste as a surface ground – I used it to cover the whole of a small piece of mount card. Once it had dried, I added the shapes of the rocks as a second layer. When this area was completely dry I painted the landscape using paint, ink and granulation medium.

You can build up great depth in the texture using this medium, but this is best done in layers if you want obvious definition in the details like this.

Painting *Sunflowers*

The two types of paste can be worked together at the same time; rest assured that you won't end up with any cracks. In this sunflower painting, for example, I used both coarse and fine modelling pastes: the coarse paste depicts the lovely raised textured of the flower centres while the fine modelling paste suggests the smoother petals of the main flower.

I started the painting by drawing the sunflower heads on a piece of 640gsm (300lb) watercolour paper with a Not surface, then used a palette knife to apply the two pastes as normal, blending them together a little at the edge of the central area. When the pastes had dried, I painted the flowers – mainly with cadmium lemon, but also using some Indian yellow to outline the petals and give a bit of variation. Sepia acrylic ink and granulation medium were added to the centres, allowing it to run down and around the petals in some areas. I also used green apatite genuine to suggest some leaf shapes. As this was being framed behind glass, no protection spray was needed.

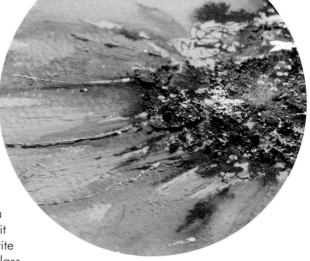

The contrasting physical texture here helps to emphasize the watercolour work.

TISSUE PAPER

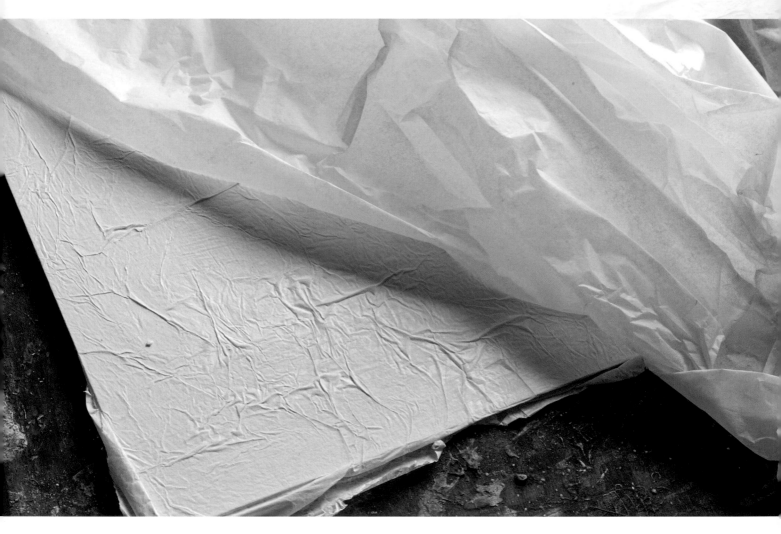

Some really unusual effects can be achieved when using tissue paper as a base to work on. To give it strength, the tissue paper needs to be fixed to a support – you can use paper, boards, canvases or mount card. I use fine watercolour ground to prime a surface and then, after scrunching up the paper, place it directly on top and press down while the ground is still wet. With the tissue roughly in place, I then cover it with more watercolour ground and allow it to dry.

 This results in a strong, rigid surface for watercolours. When the paint runs into the crevices, it becomes really interesting, leaving the raised, creased surface to catch the light – or to be emphasized by highlighting with a light shade of paint or bronzing powders: skating these over the tissue paper surface will help pick out and suggest textures.

You can buy tissue paper from most craft shops and in bulk online.

Creating a tissue paper base

1 Pour some fine watercolour ground into a pot.

2 Add half the amount of water (the correct proportions are two-thirds ground to one-third water), then stir to create a smooth, fluid mix.

3 Take a piece of tissue paper slightly larger than your surface, scrunch it up, then open it back out.

4 Paint the watered-down ground over the whole surface.

5 Lay the tissue paper on top, and press it down lightly to secure – don't squeeze out all of the wrinkles.

6 Paint over the top with the watered-down ground, again covering the whole surface, then allow to dry.

Using a tissue paper base

Once a tissue paper surface has been prepared and left to dry, watercolour can be applied in the same way as if using a normal piece of paper. The wet paint will naturally run into the crevices and recesses and produce some stunning effects.

Masking fluid cannot be used on a tissue paper surface as it would tear the paper when removed.

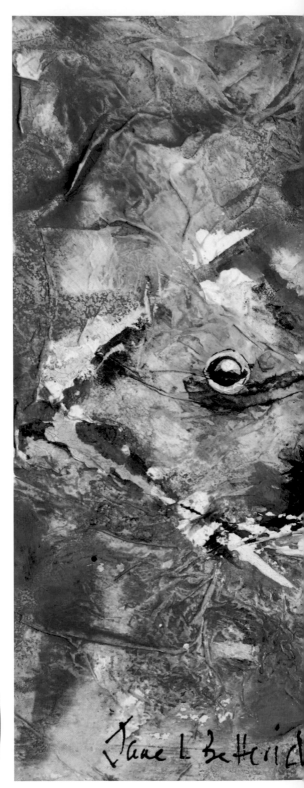

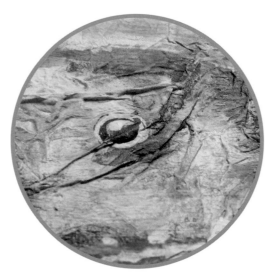

Work selectively

You can safely ignore any creases; just paint as though they were not there. Alternatively, you can choose to deliberately emphasize them.

Texture

The texture the tissue paper creates makes the paint act differently from normal, sticking in some of the creases and mixing with other colours to make unusual effects like those shown here.

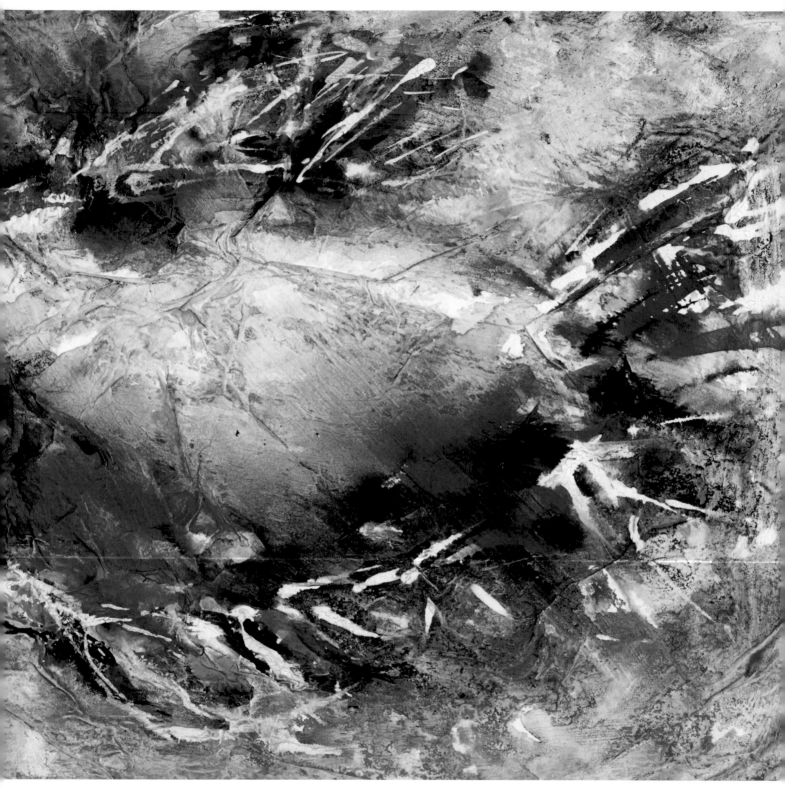

Painting *Fishy Business*

Painted over a base of tissue paper, I added highlights to the fish
using white gouache and ink once the watercolour had dried.

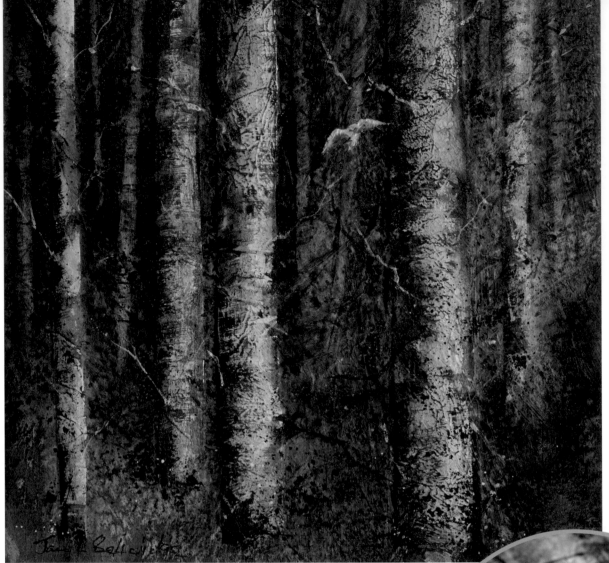

Painting *Mysterious Woodland*

This mysterious woodland is painted on canvas, with a tissue paper surface that covers and seals strips of watercolour paper in place. These strips act as the basis for some of the trees in the painting, giving a slightly raised effect under the tissue.

I started by cutting out strips of 300gsm (140lb) watercolour paper in various sizes. I then primed the canvas with watercolour ground, before placing the strips of paper on top of the wet ground. I then covered these with another thin coat of ground. While it remained wet, I scrunched up a piece of tissue paper, opened it out again and placed it on top, flattening it out slightly. I then coated this with a final layer of ground, before letting it dry thoroughly. All the layers help to seal and secure everything in place while leaving it workable to paint upon.

The painting itself was made by wetting the paper between each strip and adding nordic blue watercolour paint. While wet, I sprinkled salt into it (see page 102) for texture. I let this dry and then, using a damp brush, dragged some of the paint into the tree trunks to create shadow before letting them dry. I added more definition to the trunks with the blue paint, making use of the textured surface that the tissue paper had created. I used an acrylic angle shade brush to lift out (see step 25 on page 131) some distant trees, and add a few of the markings. When dry, I used both the blue paint and some white acrylic ink to paint in some branches. White gouache was used for the owl and I spattered a little of the paint in the foreground. When completed, I sprayed it with a watercolour fixative to protect it.

Layering the tissue paper over the strips helps to secure them to the canvas, but it also helps to integrate them, preventing them looking stuck-on and artificial. The folds and creases in the tissue paper help to suggest the texture of bark and fine branches.

Painting *Bluebells and Cow Parsley*

This variation was painted on mount card primed with watercolour ground. While wet, I put some honesty seed heads onto the ground, here and there, and covered them in ground too before putting tissue paper on top as normal, and letting it dry completely. When paint was added, a suggestion of the honesty seed heads' shape shows through the paper.

The combination of the circular shapes of the honesty seed heads and the creases of the tissue paper look really interesting when paint is added.

METALLIC LEAF

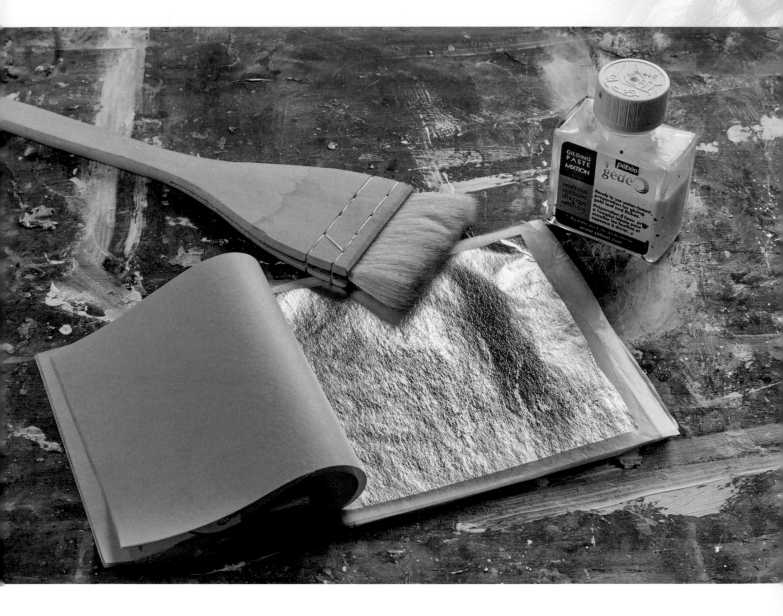

There are several types of metallic leaf: gold, silver and variegated (patterned). It comes in little pads with each extremely thin leaf on tissue paper. Most artists use the imitation metal leaves, which are quite cheap to buy, but you can buy real gold and silver leaf, which are – for obvious reasons – a lot more expensive.

Gilding is a traditional method used for applying gold to wood and plaster and requires a special adhesive called gilding paste to make it stick. This is applied to a non-porous surface and then left for fifteen minutes to dry slightly and become tacky. A sheet of the metal leaf is placed directly on to where the glue is and, when pressed down, will stick to the adhesive. A soft brush is then used to brush off any excess.

Properly speaking, a varnish should be applied to seal and protect the metallic leaf once the adhesive has dried. I sometimes use transparent watercolour ground for this, but I often leave it unprotected if it is to be framed behind glass as I find that any of the protection mediums can dull the gold effect.

Poppyfield

When I saw the photograph of this lovely, golden field of corn interspersed with the bright red poppies, I knew I had to paint it. I naturally thought of gold leaf as a base, hoping the gold would shine through here and there.

This longer project will not only teach you how to use metallic leaf but also show you how to incorporate it into your paintings, along with some of the other techniques in the book.

You will need

Paints: Indian yellow, green-gold, perylene green, pyrrol scarlet, titanium opaque white

Brushes: old brush (I used a size 12 round that had lost its point), large soft hake brush, size 10 round, size 6 round, size 0 rigger, 13mm (½in) rake

Surface: piece of mount card 15 x 21cm (6 x 8¼in)

Other: gilding paste, imitation gold leaf, transparent watercolour ground, kitchen paper, gold contour gel, pipette, palette knife

1 Use the old brush to cover the whole surface of the mount board, right up to the edges. There's no need to worry about brushstrokes; just be careful to cover the whole surface. Rinse the brush immediately afterwards, and let the surface stand for fifteen minutes. It will not dry completely, but will go tacky.

2 Take your first piece of gold leaf and lay it face down on the sticky surface. Most sheets of gold leaf have one side that has no margin on the backing; this is to help you when covering areas larger than the sheet – make sure that you lay it on to take advantage of this.

3 Cover as much of the surface as you can using the full sheets. Press down firmly, then carefully peel away the backing from each sheet.

4 Fill in any gaps using smaller pieces cut from larger sheets.

5 Use the large soft hake brush to sweep away any unsecured gold leaf.

6 Cover the surface with a thin layer of transparent watercolour ground. Use an old soft brush, both to avoid visible brushstrokes, and to avoid damaging the surface.

7 Small gaps will appear as the ground begins to dry, showing the gold leaf through the ground. Don't worry about this – we want some to show through. You can control the amount that shows by continuing to move the ground around as it dries. It will gradually reveal less and less.

8 Once dry, the surface is ready to paint upon. Prepare your paints, making them slightly thicker than usual – around the consistency of double cream (see inset).

9 Use the size 10 round brush to add some titanium opaque white in the top right-hand corner, favouring diagonal strokes from lower left to upper right.

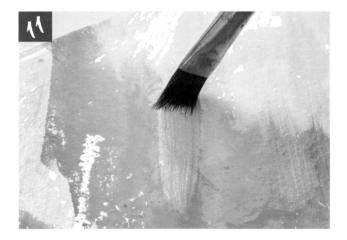

10 Start adding Indian yellow in the opposite corner, and build it up in areas across the painting, mainly in the lower half. Again, aim to create a sense of movement from bottom left to top right.

11 Use the rake brush – a special flat brush with different length bristles – to draw the wet yellow paint up into the white area.

12 Add areas of green-gold here and there in and around the yellow areas.

13 Still using the rake brush, build up some darker-toned areas across the painting using perylene green, particularly in the top left-hand corner. Allow the painting to dry – owing to the glossy surface, it will take longer than usual to dry.

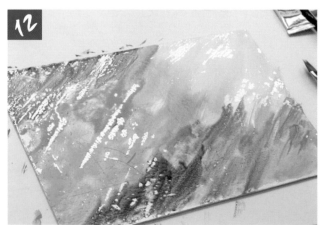

14 Switch to the size 6 round brush and use pyrrol scarlet to add some loose poppy shapes across the painting. Make these larger towards the foreground and, as earlier, try to suggest a general sense of movement from bottom left to top right through the placement of groups of poppies.

15 Brush a little pyrrol scarlet onto the bottom of the palette knife (see inset), then hold the knife a little above the surface and draw your finger across the tip to spatter some paint over the poppies, particularly around the more distant ones at the top.

16 Change to a rigger and add some fine stems to the poppies with short sweeping strokes of perylene green.

17 Using very thick perylene green, dot in centres to a few of the poppies. Avoid the temptation to paint a centre in every poppy, as that would look very unnatural.

TIP

For more information on the spattering technique, see page 84.

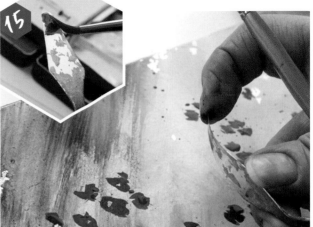

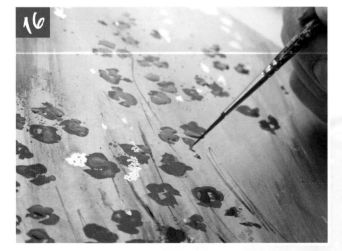

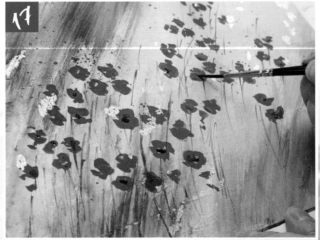

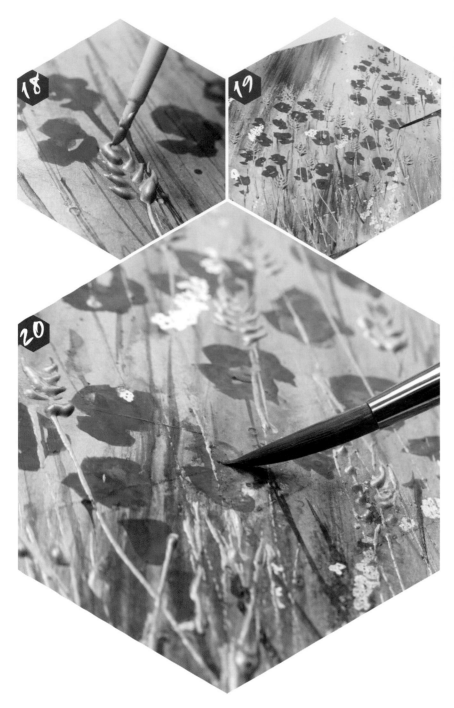

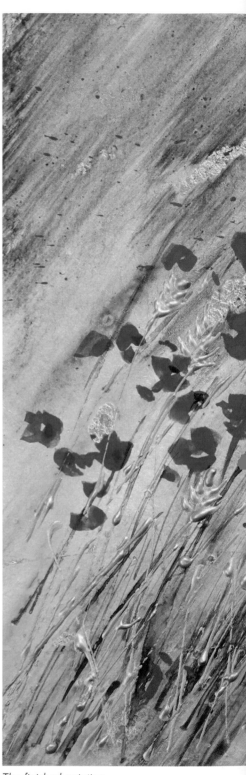

The finished painting.

TIP

To avoid smearing or smudging the contour gel with your hand, work from left to right across the painting. (If you are left-handed, work in the other direction.)

18 Once the painting is completely dry, add some ears of corn with the gold contour gel by adding a long stem, then two rows of short marks on top.

19 Continue building up the corn across the painting. Add a few extra marks near the bottom of the picture for extra texture and interest.

20 Add a few extra marks using the size 6 round brush and pyrrol scarlet to finish.

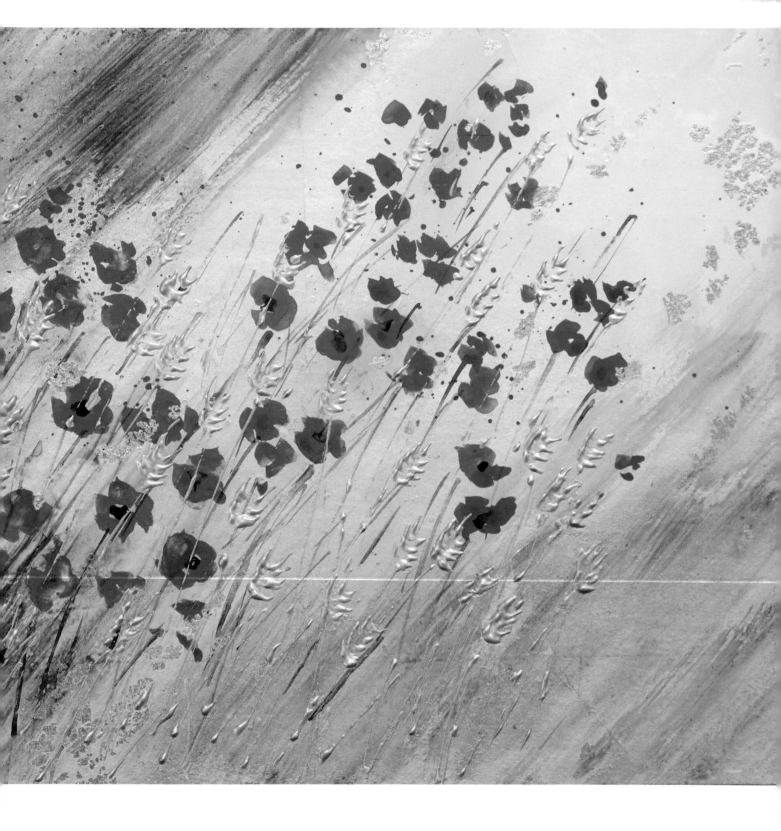

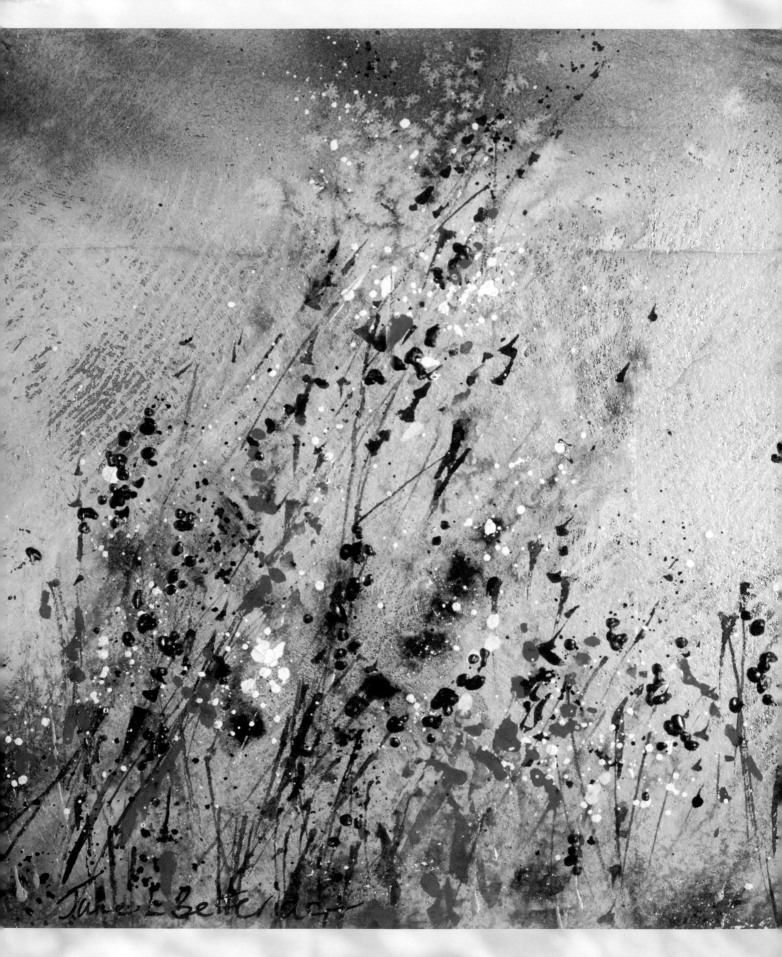

Using silver leaf

Gold metal leaf creates a warm rich feeling to a piece of work, but why not try silver for a chillier but no less striking effect?

Metallic leaf and contour gel

Copper contour gel was used to add detail. Complementing the silver leaf well, the colour adds a hint of warmth without overwhelming the frosty atmosphere.

Painting *Frosty Moorland*

I painted this frosty moorland scene in just the same way as the poppy field on the previous pages, but used silver metal leaf as the base rather than gold.

GILDING FLAKES

Gilding flakes are, essentially, little pieces of metal leaf, and most of the lessons learned for leaf (see pages 54–61) apply to these, too. You can get them in gold, copper and silver colours and they are applied in the same way as the metal leaf is. I like to apply them quite liberally.

I really embrace trying out techniques to make my paintings that bit more interesting and using gilding flakes is one way of doing this.

Adding gilding flakes to specific areas

Like metal leaf, gilding flakes need to be secured to the surface using gilding paste. After applying the metal leaf adhesive to an area of a piece of work, I sprinkle them out of the packet and let them fall on the paper in a haphazard way, creating an interesting, looser effect than that achieved by using leaf.

However, if any pieces are needed in a specific area, you can use tweezers to pick up gilding flakes individually and place them where needed, as shown here.

1 Use an old brush to apply gilding paste to your painting, where you want the flakes to sit.

2 Use tweezers to apply the gilding flakes, then allow to dry completely.

Protecting gilding flakes

Like metal leaf, gilding flakes are fragile. You can carefully cover them with grounds or special metal leaf varnish to help protect them. When the adhesive has dried, simply use transparent watercolour ground to protect the flakes as though priming the surface (see page 25 for the technique).

Generally, I prefer to leave gilding flakes uncovered wherever possible, as the finish tends to be dulled down a little when covered. If I am putting the painting behind glass, for example, I don't cover them with anything.

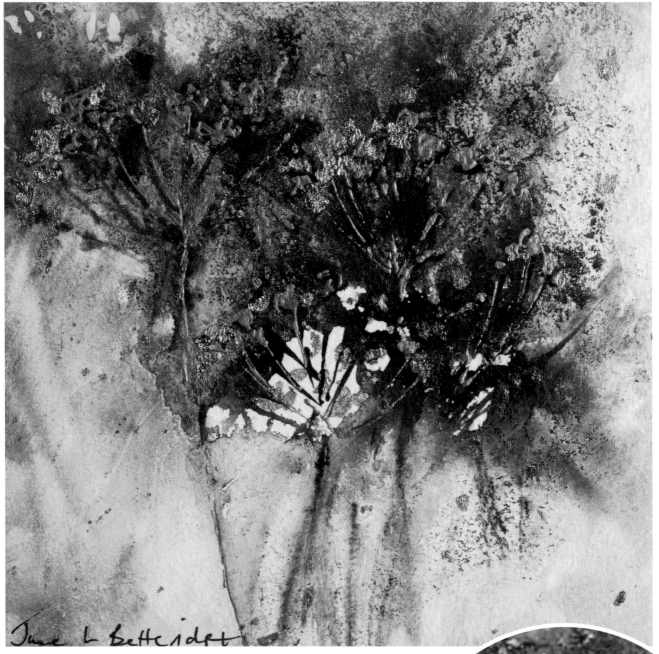

Painting *Golden Hogweed*

Gilding flakes add the finishing touches to this painting of golden hogweed. I began with a background of raw umber watercolour paint and some sepia acrylic ink, to which I added some gold bronzing powder to develop the detail of the seed heads. I also spattered a little here and there.

When the composition was nearly completed, I decided to enhance it even more by using gold gilding flakes in a controlled way. As described on page 61, I painted on the gilding paste, then used tweezers to place the individual flakes exactly where I wanted them.

The shimmer of gold gilding flakes adds real impact and contrast to this atmospheric depiction of hogweed

Painting *Silver Cow Parsley*

Having made a simple sketch of two cow parsley seed heads on 640gsm (300lb) Not surface watercolour paper, I painted on some transparent watercolour ground here and there, making sure it covered the seed head area, but not the whole surface of the paper. I then sprinkled silver coloured gilding flakes in a random fashion, straight out of the carton, but made sure that some fell around the seed heads. I then covered these with watercolour ground, which caused some of them to clump together – a happy accident that helped to create texture. I then left it to dry.

After the preparation of the surface, I wet the paper all over and painted a wet in wet background using French ultramarine, indigo and turquoise watercolour paints and added salt to create a speckled, frosty background. I also spattered a little white acrylic ink around the top of one of the seed heads. When it was dry, I painted in more detail to the cow parsley and then added some more gilding flakes. Using the special adhesive, I placed them exactly where I wanted them by picking each one up with a pair of tweezers. You can see the difference between the less vibrant flakes which are covered in the ground, compared with the individually placed ones which were left uncovered; these are much more vibrant.

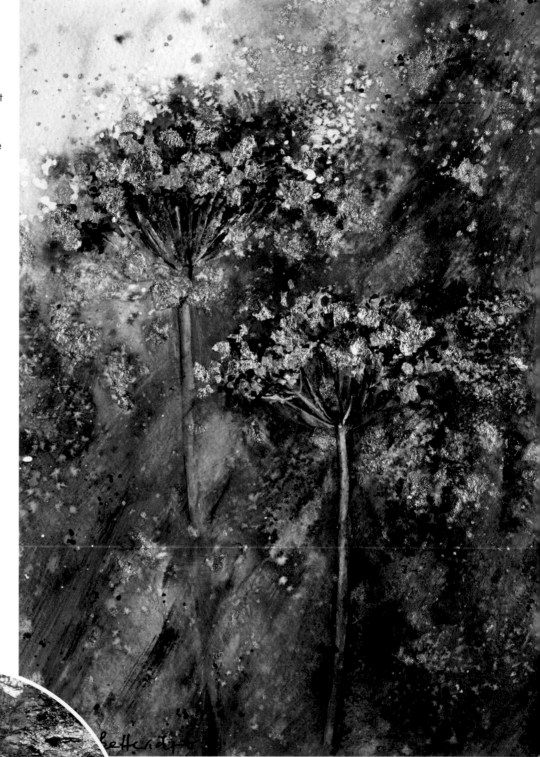

Silver and blue are a classic combination that evokes nighttime. The glittering silver gilding flakes provide great contrast with the dark blues and indigo paints used.

WIRE BRUSH

I stumbled across the technique of using a wire brush to distress my paper, quite by accident. I used some paper one day that had been left in a drawer (where I keep some old pieces or work that I will, probably, never finish). I started to paint as usual and noticed that the paint was running and behaving differently in one particular area. On closer inspection, I saw that the paper was damaged and had been scratched in several places by something (this was probably why I had relegated it to the 'unfinished work drawer' several months earlier). I thought the effect of the scratches could be quite useful to add a little variety in some parts of a painting. This accident gave me the idea to distress my paper in a more controlled way by creating scratches in the direction and shape that I wanted them to be. With this in mind, I raided my husband's tool box for a wire brush and found a lovely little set of three; about as big as large toothbrushes, and in various strengths. These are available from DIY stores.

Distressing the surface

The technique is as simple as scraping the wire brush over your watercolour paper. This will subtly damage the surface, which will cause the paint to behave differently.

Repeatedly scraping in the same direction over an area in lines or curves will allow you to create the suggestion of movement and dynamism in your work, as shown in the example below.

Autumn Meadow

This simple landscape demonstrates the effect you can achieve by using a wire brush before starting to paint. After drawing a very simple outline of a distant horizon line, about a third of the way down the paper, I used a wire brush to scratch the surface of the sky area with downward curving strokes, and the foreground with upward-curving strokes. I wetted the paper down to the horizon, then, leaving a very small, dry line next to the pencil line, carried on wetting the rest of the paper down to the very bottom. I dropped in burnt umber and French ultramarine to colour the scene, and used a mixture of the two together for the black cloud.

When this was dry, I painted in the foliage marks and teasels using a combination of the same colours. You can see where the paint ran into the scratches made by the wire brush giving interesting directional marks.

STAMPING INTO THE SURFACE

A really exciting technique, which creates a wonderful surface to work on, is stamping or printing into the surface of watercolour ground, both smooth and coarse. This simple mark-making method is a wonderful way of adding texture, interest and excitement to your work.

It's a very easy procedure: simply cover a board, canvas or mount card with your chosen watercolour ground and stamp either organic or any found objects which are of interest to you, into the ground. I find leaves, twigs, flowerheads, grasses, shells, coins, gauze, cotton thread, skeleton leaves, bubble wrap, and food wrap all work well.

Once the surface has been covered, arrange your chosen objects in a pleasing composition and press them into the watercolour ground. When the ground is nearly dry, say after about an hour depending on how thickly it's been applied, very carefully remove them (I often use a pair of tweezers for this), revealing the lovely shapes and patterns that they have made. The ground should still be tacky so it is necessary to let this dry thoroughly before starting work.

The fun starts when you add paint and watch it flow into the marks; it really is a great way to have some fun. The picture more or less paints itself!

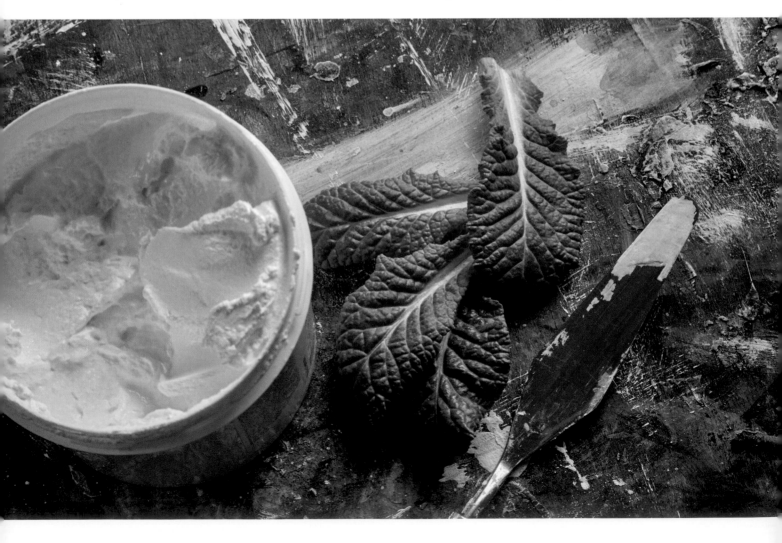

Stamping into the surface

This technique will work on any surface covered with watercolour ground as described on page 25. Any watercolour ground (coarse or smooth) can be used.

1 Take your 'stamp' – in this case a primula leaf – and press it firmly into the still-wet ground.

2 Carefully peel the stamp away to reveal the effect. Depending on what you're printing into the surface, you may need to wait half an hour or so for the ground to set sufficiently to retain the detail.

3 Repeat as necessary, then allow the whole surface to dry completely.

Textured Leaves

I covered a piece of mount card with coarse watercolour ground using a palette knife, then pressed some lupin and primula leaves into the surface. I let the ground nearly dry before I removed them and then left the newly textured surface to thoroughly dry. Using paints, inks and gold bronzing powder, I wet the surface all over and let the paint run and meander its way through the little channels that the leaves had made; adding the gold last of all. I then sprinkled on some salt and left it to dry. To finish off, I used sepia acrylic ink to suggest some twigs in the background. I sealed the painting with a protective spray after I had completely finished and it had dried.

Beach Scene

After covering various surface preparation techniques in this section, let's try doing a project that incorporates some of them: it's really simple.

Using a chunky canvas wooden panel and mainly coarse watercolour ground, and incorporating crackle paste towards the foreground, forms an interesting textured base upon which to paint this seascape.

1 Using the large palette knife, apply coarse watercolour ground to the upper three-quarters of the canvas. Aim to cover the canvas texture completely, and use long, large strokes to create an interesting surface. You won't be able to get it completely smooth, but there's no need to deliberately create large peaks.

2 Cover the lower quarter of the canvas with crackle paste. Apply the ground to cover the canvas surface completely without being overly thick – essentially, as thin as you can get it while still completely hiding the canvas. Work the paste up into the coarse ground, so that the lower half of the painting is covered by the crackle paste. Leave this to dry completely – it can take up to two days for the crackle paste to develop completely.

3 Use a 2B pencil and ruler to add a faint horizon line about quarter of the way down.

4 Prepare your paints to a single cream consistency and use the size 16 round brush to wet the areas above the horizon with clean water, then switch to the size 10 and paint Prussian blue in wet-in-wet at the top. Rinse your brush and blend it down towards the horizon.

5 Drop turquoise ink into the wet paint.

6 Tip and turn the canvas to encourage the colours to mix and merge.

7 Use the pipette to add granulating medium to the wet paint.

You will need

Paints: sandstone, Naples yellow hue, Prussian blue, titanium opaque white

Inks: turquoise, white and burnt umber acrylic inks

Brushes: size 16 round, size 10 round, size 6 round, size 0 rigger, 13mm (½in) rake, old size 4 round

Surface: wooden canvas panel 31 x 31cm (12 x 12in)

Other: large and small palette knives, crackle paste, coarse watercolour ground, granulation medium, rich pale gold bronzing powder, gloves, pencil and ruler, kitchen paper, and pipette

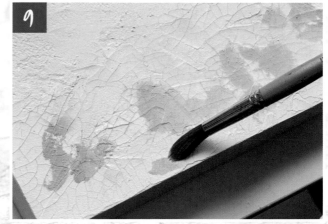

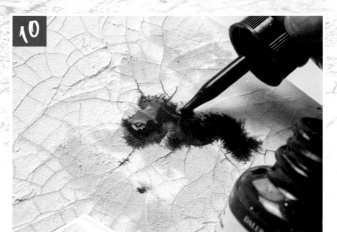

8 Leaving the sky area to dry, use the size 10 round brush to paint Naples yellow across the lower half of the painting to represent the beach. Leave a few gaps, but encourage the colour to fall into the cracks.

9 Add sandstone paint wet-in-wet for variation, applying it mainly near the edges.

10 Drop burnt umber ink into the beach area, mainly at the corners – avoid adding too much, as it is quite dominant.

11 Add granulating medium to the area, then tip and tilt the board to encourage the wet paint and ink to flow into and around the cracks (see inset).

12 If the tone is too heavy, you can use clean kitchen paper to dab the surface and lift out any excess. This will also suggest highlights and the gloss of wet sand. Leave the painting to dry for fifteen minutes.

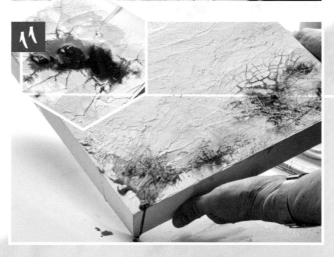

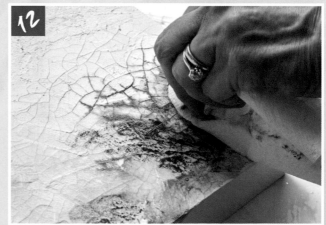

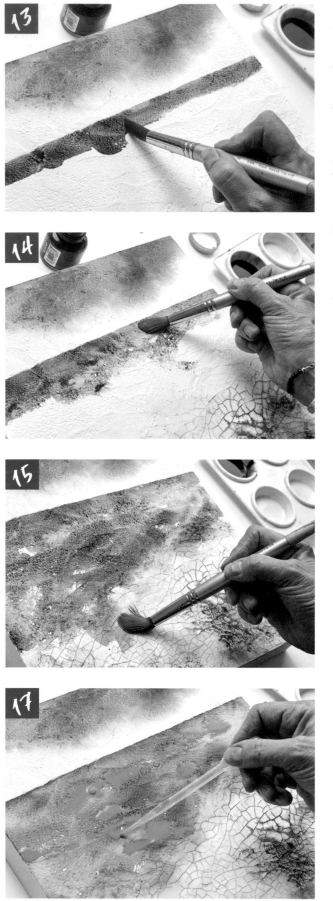

13 Use the size 16 round brush to paint a line of Prussian blue below the horizon.

14 Rinse the brush lightly and blend the colour downwards over the sea area.

15 Rinse the brush again and encourage the colour down over the dry beach area.

16 Leave the paint for five minutes or so, to dry partially but not completely. The rough surface may mean that the sea bleeds upwards into the sky area. If this happens, use dry kitchen paper to lift out the wet paint (see inset).

17 Draw the dropper of the turquoise ink over the sea in loose horizontal strokes, then add granulating medium over the sea.

18 While the paint and ink remains wet, use the size 6 round brush to add some Prussian blue strokes. Tip and tilt the painting to encourage the colours to move and blend on the surface (see inset).

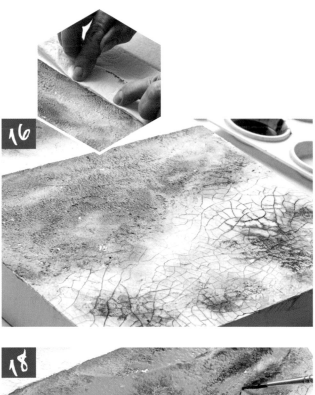

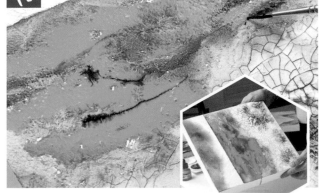

19 Use a clean wet size 10 brush to blend the colour down over the top of the beach area.

20 As the paint starts to dry, break up the flat surface with fine strokes of the rigger, using it to apply a stronger mix of Prussian blue.

21 Use swirling movements of the rigger to apply the gold bronzing powder to the sea.

22 Repeat the process with the white ink, using the side of the rigger as much as the tip.

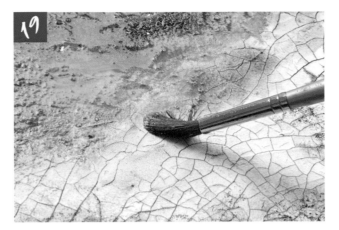

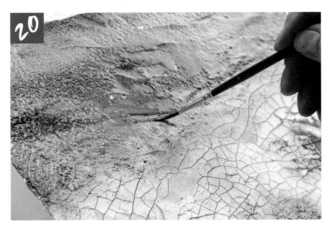

TIP

If you prepare a well of white ink a few minutes beforehand, it will start to thicken a little, making it more effective when used wet-in-wet.

23 Add touches of turquoise ink over the sea in the foreground, breaking it up with the granulating medium.

24 Using an old size 4 round brush and the gold bronzing powder, add a few gold areas to the beach, using the shapes suggested by the crackle paste to help. Aim to create a random, natural effect; and don't go overboard.

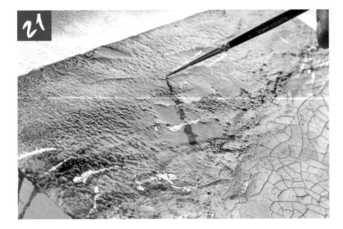

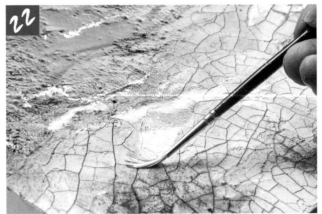

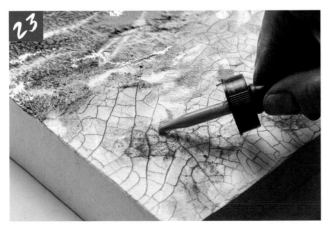

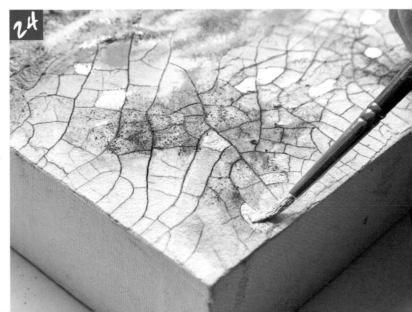

25 Add some fine horizontal strokes of titanium opaque white across the sea using the rigger.

26 Tip and hold the painting up to encourage the white ink to travel down towards the lower left-hand corner. Once you lay the painting flat, the wet ink, paint and medium on the sea will continue to develop (see inset). You can either allow it to dry completely, or turn the painting round and continue painting upside-down to avoid disturbing the sea.

27 Use Naples yellow, sandstone and the size 6 round brush to paint in a simple headland above the horizon.

28 Add a hint of Prussian blue wet-in-wet to subtly suggest shape and shadow. Use the texture on the surface to help guide your placement of these shadows.

29 To avoid the headland looking too strong and contrived, soften the base of it into the sea using dilute Prussian blue.

30 Use the rigger and titanium opaque white to suggest two or three wheeling seagulls in the sky.

31 Use the small palette knife to spatter some titanium opaque white over the foreground to finish.

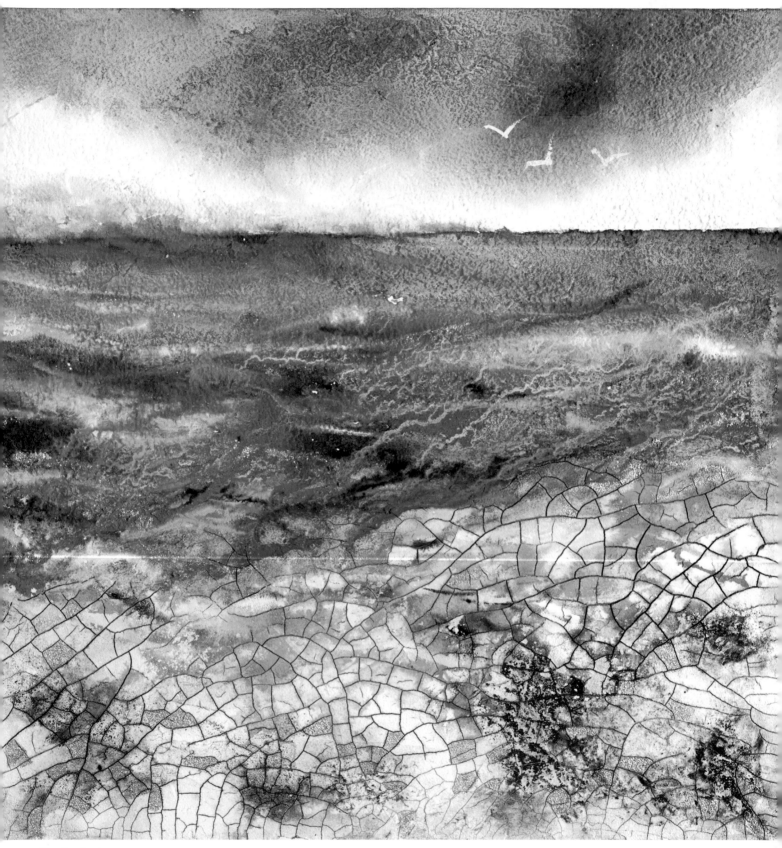

The finished painting.

ADDING TO YOUR

Now that you can create lots of interesting surfaces to work on, let me show you how to explore your painting even further. This part of the book looks at the magical, interesting, unconventional items and ingredients that can be added to watercolour to make your work even more exciting. Inks, gouache, contour gel, gauze and threads, collage, salt, plastic wrap and stencils – plus additives such as bronzing powder, granulation medium and pearlescent medium – all offer fresh ideas on how to approach your painting subjects. I have hinted at some of these in the projects and examples earlier in the book; now I will guide you through the techniques available in more detail, to encourage your enthusiasm for watercolour still further. Let's climb a few more rungs of the creative ladder to reach even greater heights with your work.

PAINTING

INKS

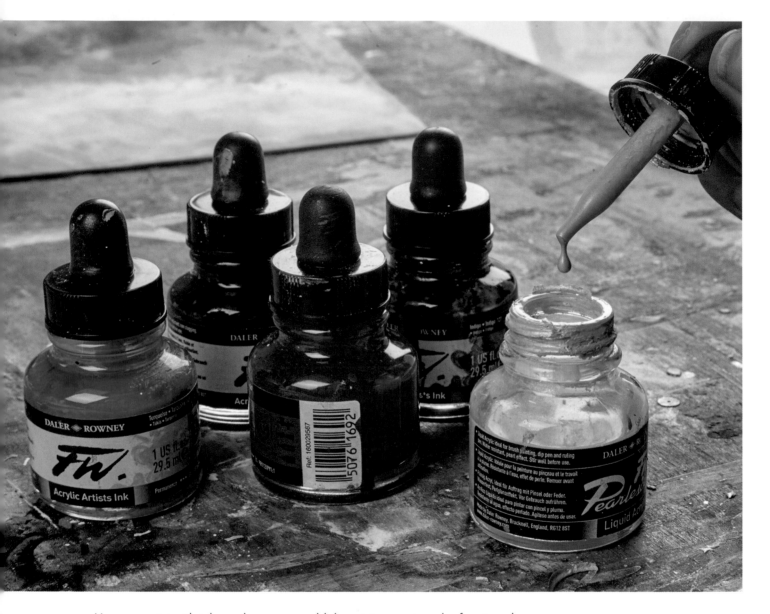

You can paint with inks as they are or add them into a wet wash of watercolour for dramatic effect. The inks I use come in small glass bottles with a pipette dropper in the lid. Ideal for either dispensing into a palette or for drawing straight onto a piece of work. Also available are pearlescent and shimmering colours, which are nice to use for something a little different.

Some inks are water-based (like string dyes), while others are acrylic-based. I prefer the acrylic-based inks because they are thicker in consistency and have vibrancy and intensity that other inks lack. Sometimes it's nice to add that little extra 'oomph' into a painting, and acrylic inks are ideal for that. They can be mixed into watercolour paint to strengthen the colour or can be mixed together themselves to create more colours from a basic palette.

Using inks

You can use ink with a brush, much like paint. Ink is fluid enough to paint with straight away; there is no need to water it down or prepare it. The pigment is a lot stronger, and it is permanent, so bear this in mind.

1 If you are using a dropper bottle, squeeze a little ink into a small container – a bottle top is perfect.

2 Use the ink just as you would prepared paint, applying it with watercolour brushes.

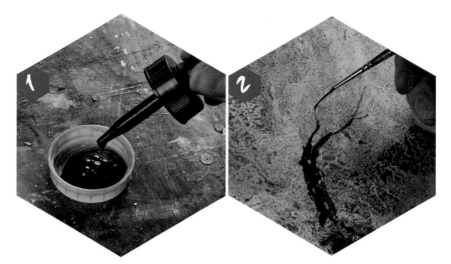

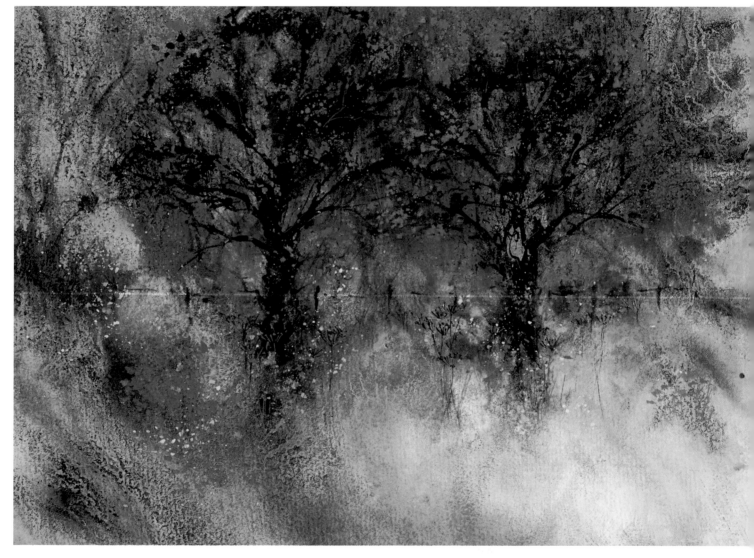

Silhouette of Trees

The dark indigo of the trees against an atmospheric ink background really helps show off the best of each medium. I spattered and moved the ink and paint around, lifting up my paper and letting it run and merge and create interesting patterns and effects before waiting for it to dry to add the trees.

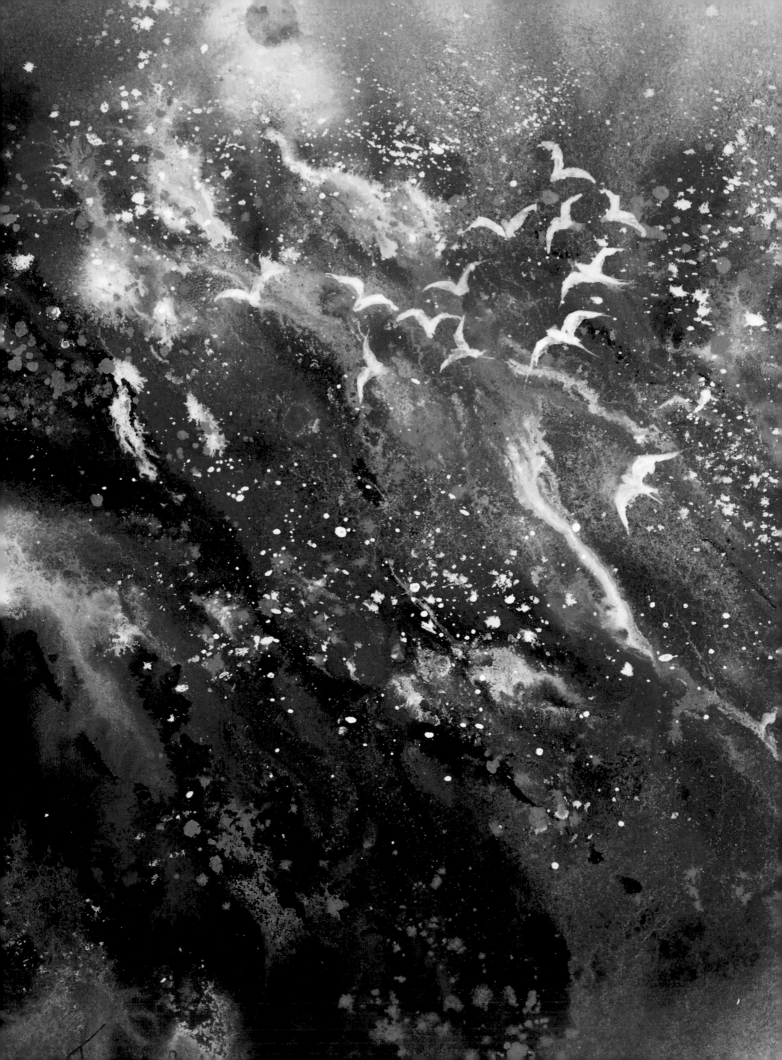

Adding ink to wet paint

Try dropping ink directly into wet paint using a brush. The pigment is strong enough to show through. White ink is particularly effective, as it is a great way to reintroduce light into your work. Tip the painting as you work to encourage it to move and flow.

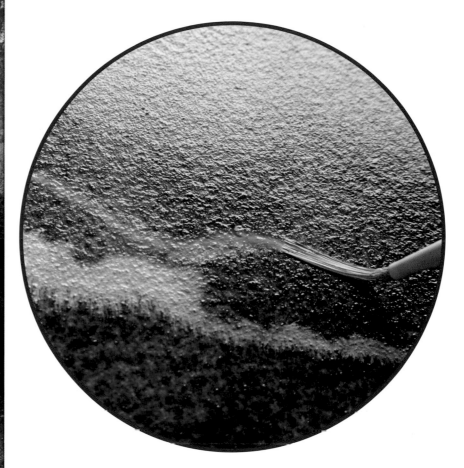

Fine marks

Ink will bleed into wet paint a little, so start with small marks – they will grow. A rigger brush is ideal to apply tiny marks

Painting *Crashing Waves at Porthmeor*

I dropped white acrylic ink into this vibrant blue seascape while it was still wet. Ink flows with wet paint but as it has a stronger consistency, it will not simply disappear into the wash and shows up really well. The seagulls were painted in white ink when the initial wash was dry.

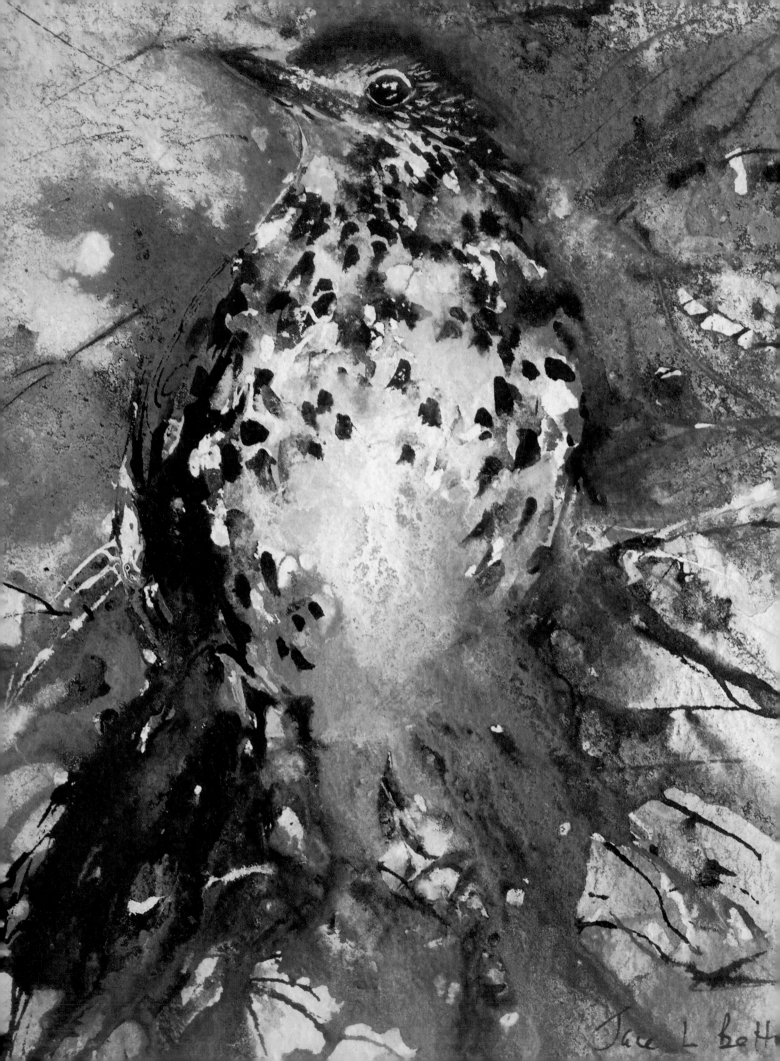

Applying ink to dry paint

Ink can be used over the top of a dry watercolour base – as shown in the example here. By doing this selectively, the unique effects of watercolour washes remain as background, while other areas are given more impact. More intense subject matter can also be added in ink to give paintings more 'punch', as shown on page 85.

Coverage

Unlike watercolour paint, ink is opaque, so it will cover any dry paint beneath it. Grey ink was used here, resulting in a subtle, soft, ethereal effect that complements the warmer brown tones.

Painting *Songbird*

The grey ink in this painting of a thrush was added after I had finished painting the bird and let it dry. I felt it was not quite as interesting as I would have liked, so I added the ink and let it run down the paper, but blended it into the bottom of the bird's breast.

Spattering

This technique lets you scatter paint or ink in a semi-controlled way, creating speckles that can be interpreted as shapes such as leaves and flowers. This is a quick way to build up suggested detail, and gives a great impression of movement to your work. Lots of spattering using inks on top of a dried watercolour wash adds extra interest to a basic watercolour painting.

1 Use the dropper to add dilute paint or ink to the back of the palette knife directly.

2 Bend the tip of the knife back, hold it over the area you want to spatter, then pull your finger over so the knife springs back into place.

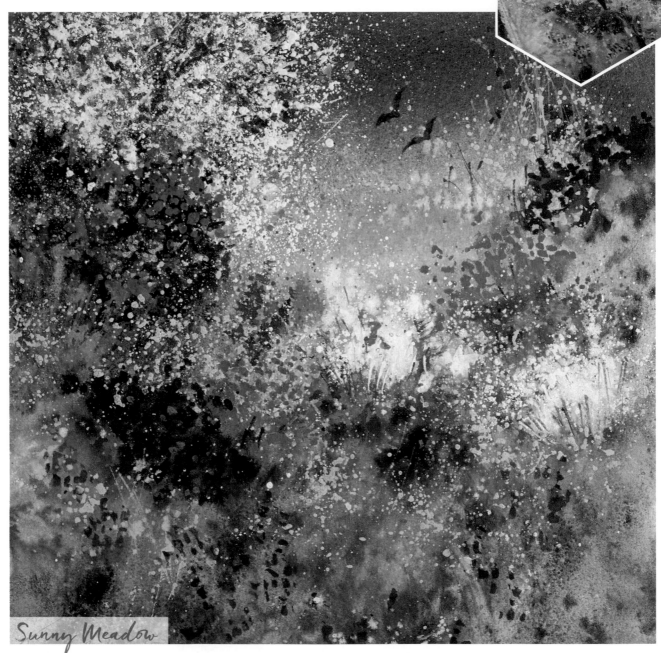

Sunny Meadow

Opera rose watercolour was spattered over the tree to bring the blossom to life. I also spattered white ink in areas to lift the relatively dark background wash. While it remained wet, I dragged a palette knife through it to suggest stems of cow parsley.

Brightening a dull painting

Strong, bright ink can be applied directly to lift a painting that has become too dull or monotone. Use the dropper itself to draw the line.

*There's no need to squeeze the bulb
— just let the ink flow out naturally.*

Fallen Leaves

I felt this watercolour I had painted of fallen autumn leaves was a little dull. I'd added salt and lots of autumnal colours but felt that it lacked a bit of sparkle. So I used lime green pearlescent ink to outline some of the leaves to inject a bit of interest, colour and pattern and bring it back to life.

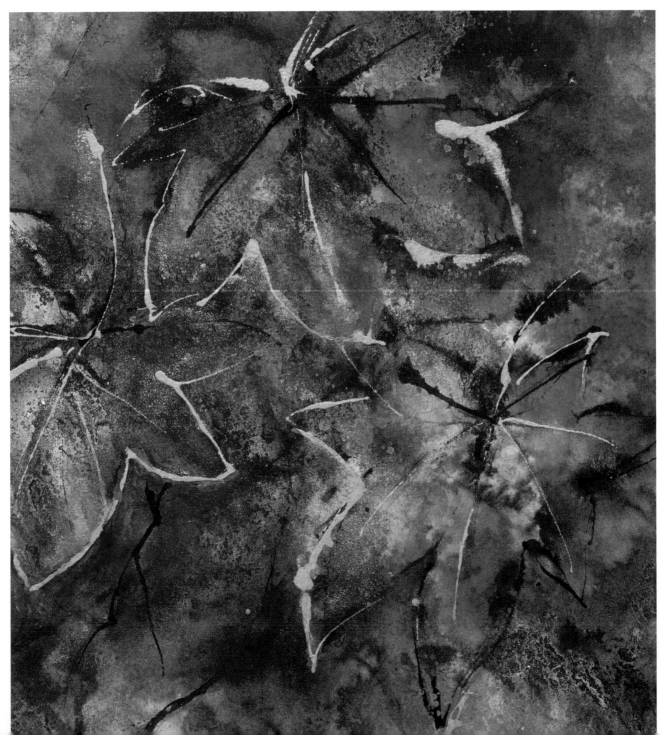

GRANULATION

One of my favourite products to use, granulation medium is a colourless liquid and is available to buy in small bottles. When added to paint or acrylic ink, it splits the pigment and creates remarkable effects.

I add granulation medium to my watercolour paints when preparing a mix or use a pipette to dribble it into wet paint on the paper. It has a more intense, powerful result when used in the same way with acrylic inks.

The Pink Sky

For this painting I used watercolours in a fairly conventional way, but then added some indigo ink in the foreground and in the distant bushes. While wet, I used a pipette to dribble granulation medium into the ink to get the speckled effect.

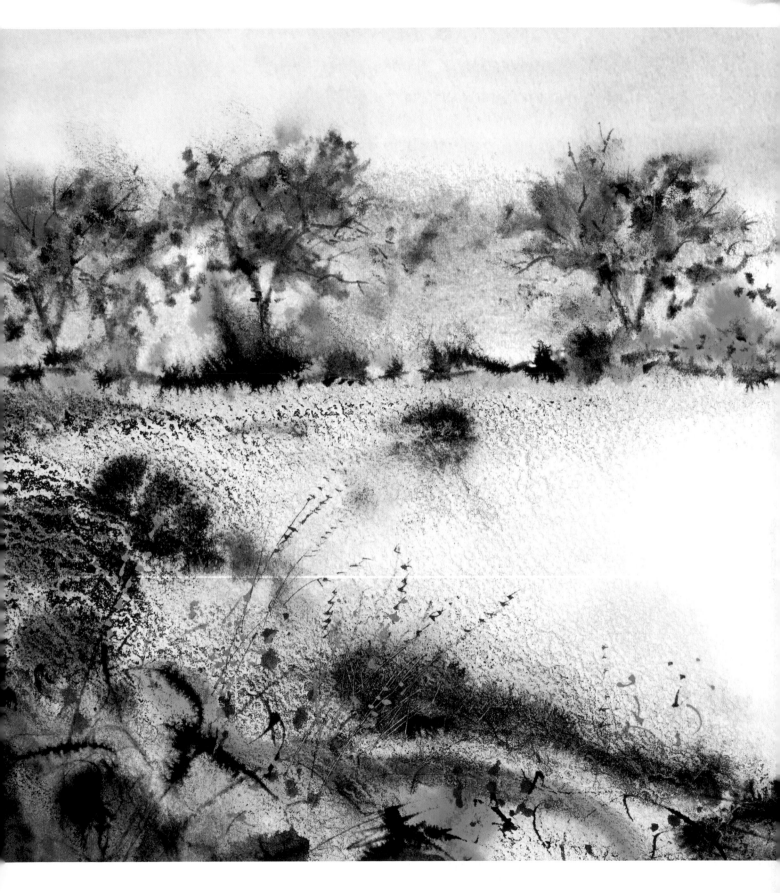

Adding granulation medium to paint

You can add the medium when preparing the paint in the palette, which gives a more subtle effect (see *Landscape Blues*, opposite), or for a more directed and obvious result, add it to wet paint on the surface. Because it interacts with the paint, granulation medium will work with any surface to which you can apply watercolours, from paper to canvas prepared with watercolour ground.

1 Paint your surface as usual.

2 While the paint is wet, use a pipette to add granulation medium. The finished effect will vary depending on how wet the surface is.

3 You can tip and tilt the painting to help encourage the effect in certain directions.

4 The effect will develop over time as the paint dries. The finished result will look something like this.

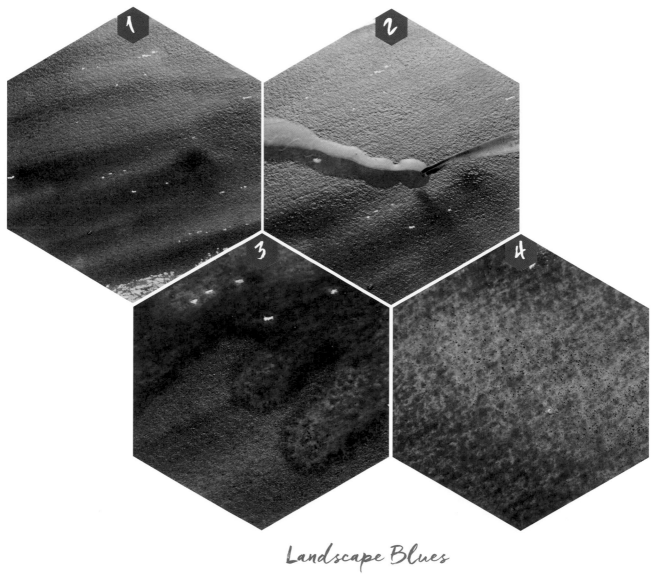

Landscape Blues

I laid a background watercolour, wet-in-wet wash using ultramarine blue and transparent umber for the sky and distant land. The granulation medium was added to the paint whilst mixing the colours in the palette. This gave me the subtle, soft effect I wanted. I intensified the colour at the bottom and dropped in some cotton thread, quite thick pale blue paint, some sepia ink and then dribbled in the granulation medium. I waited until it was completely dry before removing the thread and then added a bit of bright orange spattering.

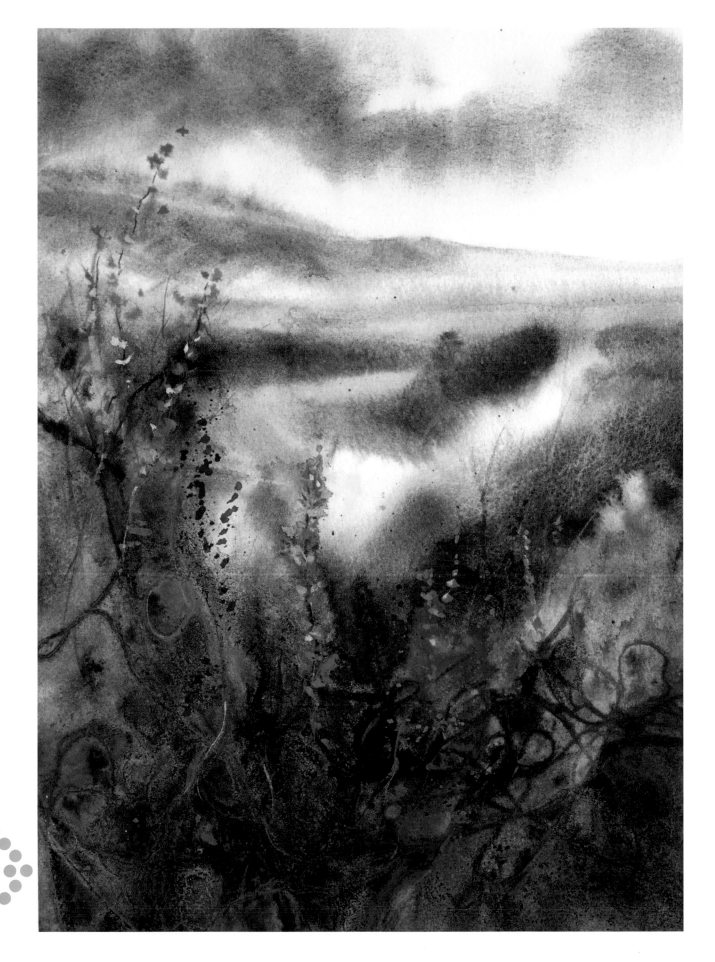

Adding granulation medium to ink

The technique for adding granulation medium to ink is nearly identical to using it with watercolour paint. The effects of the medium with ink are particularly striking.

1 Wet the surface with clean water.

2 Add your ink into the wet surface – here I am applying it directly from the pot using the dropper.

3 While the ink remains wet, add granulation medium with the pipette.

4 Tip and tilt the painting to encourage the ink to flow, then leave it undisturbed to dry.

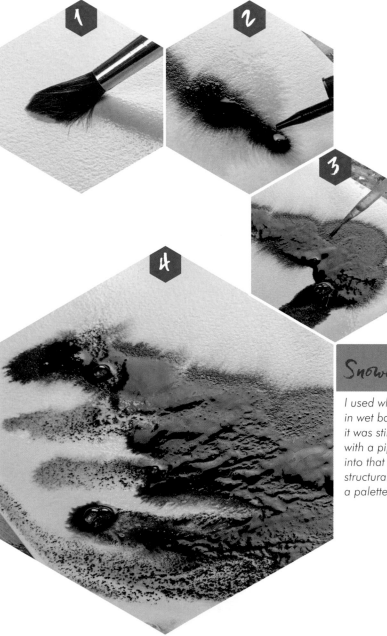

Snowy Mountain

I used white, grey and sepia ink to paint a wet in wet background for this wintry scene. While it was still damp, I added some more sepia ink with a pipette and then granulation medium into that here and there to give some hard structural shapes. I also spattered white ink with a palette knife to give the impression of snow.

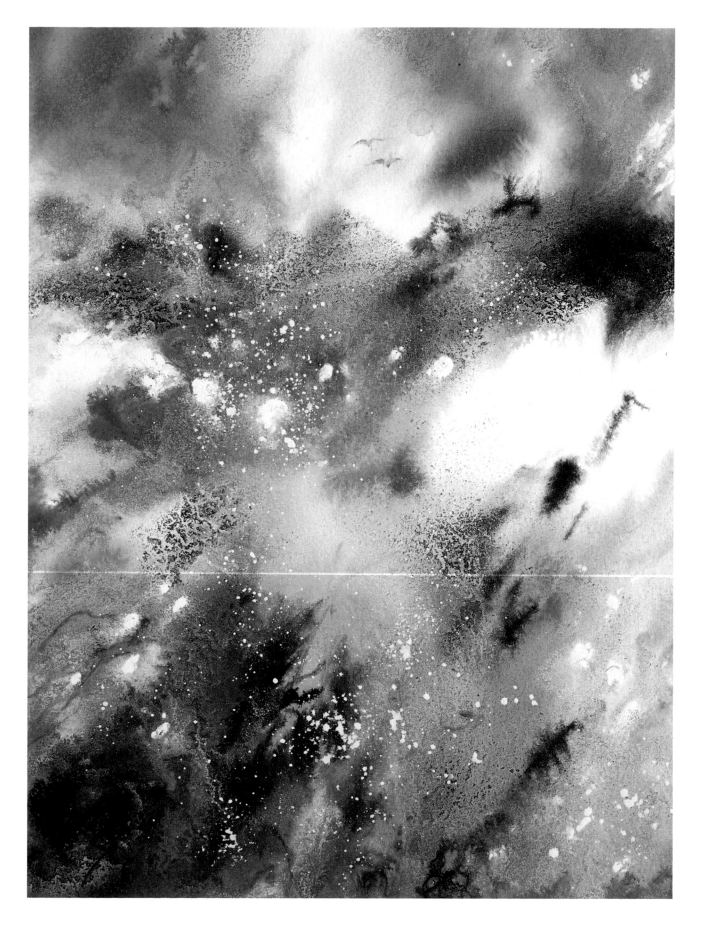

Magical Woodland

The warm, cheerful, bright, sunny colours of summer inspired me to paint this uplifting woodland scene.

Before you begin, prepare wells of French ultramarine, indigo, olive green and bright violet all to a single cream consistency; and Indian yellow to a slightly more dilute consistency. Use separate size 10 brushes for all of the main colours (you don't need a separate brush for the indigo); this will save you from having to repeatedly rinse your brush, and help you to work more quickly.

You will need

Paints: Indian yellow, French ultramarine, indigo, olive green, bright violet, leaf green, cadmium lemon, Vandyke brown, verditer blue, opera rose

Inks: sepia acrylic ink

Brushes: size 16 round, four size 10 rounds, size 6 round, size 2 round, size 0 rigger, large hog hair flat

Surface: Saunders Waterford high white 640gsm (300lb) Not surface watercolour paper, 28 x 38cm (11 x 15in)

Other: table salt, granulation medium

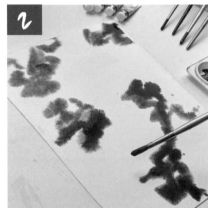

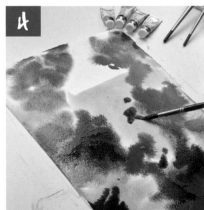

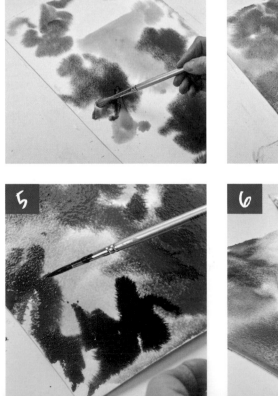

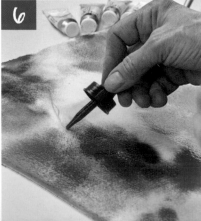

1 Starting from a third of the way down the paper, wet it down to the bottom using the size 16 brush and clean water. Leave a semi-circular area of dry paper in the sky.

2 Using trailing, gentle movements, add some areas of French ultramarine across the painting as shown.

3 Do the same with Indian yellow, adding an area below the dry paper. Allow it to bleed downwards a little.

4 Continue building up a variegated background, adding successive areas of olive green and bright violet. You can overlay some areas (adding violet over the ultramarine blue will give a particularly lovely result), but try to keep them mostly clean. Allow the wet paint to flow and merge naturally.

5 Add some indigo at the bottom of the paper with a size 6 round brush. Wet a size 16 brush and encourage the colours to merge here and there. You can draw the paint into the dry area, but leave at least part of it as pure, clean paper.

6 Use the dropper to add some touches of sepia ink. This will form some subtle texture for the tree we add later.

7 Add some granulation medium into the wet ink and use the rigger to draw the ink outwards with fine lines.

8 Before the gloss has gone, sprinkle generous amounts of salt over the painting. You can apply it over the whole surface, but avoid doing so evenly – aim for a varied, interesting surface that leads the eye around.

9 Allow the painting to dry naturally. Do not use a hairdryer, as this will spoil the result. Use the large hog hair flat brush to remove the salt.

10 Prepare cadmium lemon, leaf green, verditer blue, Vandyke brown and opera rose, all to single cream consistency, then start to add some structure to the painting by adding a tree trunk in the distance, using Vandyke brown and the size 0 rigger.

11 Wet a size 16 round brush and dampen the centre of the trunk. Use clean kitchen paper to lift out a little of the paint and soften the colour into the surface.

12 Add some verditer blue wet-in-wet, favouring the left-hand side of the tree. This will soften the colour and suggest shape and shadow.

13 Add a few other trees in the distance. Use more verditer blue for more distant trees, and less for closer ones. Blue is a cool colour, which helps to add perspective; cool colours go back while warm colours appear to come forward. Your painting will likely suggest different natural placements for the trees. Avoid the centre of the painting, and look for spaces where strong darks will provide good contrast with the lighter underlying colours.

14 Add some saplings in the foreground using fairly strong Vandyke brown.

15 Spatter some leaf green over the trees using the small palette knife.

16 Use the tip of the size 6 round to add a few more controlled marks over the same areas, helping to connect a few of the marks to suggest leaves.

17 Dot on some opera rose using the tip of the size 6 round brush. These marks are not intended to be any particular plants or flowers, but rather to create a colourful, fresh impression of woodland.

18 Spatter on some verditer blue to the midground area, then add some more considered marks; just as for the opera rose.

19 Change to the size 2 round brush and use the leaf green to suggest some ferns in the midground with curving rows of short lines. For ferns in the foreground, change to the rigger. Use the same technique, but use slightly longer lines in each row.

20 With the greens in place, begin to balance the colours and tones. For example, if your painting is dark overall, add some lighter-toned touches of pink; while if it becomes too bright, add some more darks.

21 Add some strong dark lines in the foreground, using the rigger to draw indigo up from the bottom of the paper. Use the spray bottle to soften any hard edges or shapes that you don't want: simply spray the area and let the colour bleed into the surrounding areas.

22 Change to the size 6 round brush to add some large verditer blue touches in the foreground.

23 Connect together some of the marks and shapes on the paper using the rigger, striking it through the flowerheads to suggest stems. These linear marks will lead the eye through the painting and connect larger groups of marks together.

24 Once the background trees have dried, use a pale, neutral mix of Vandyke brown and verditer blue to add some silhouetted distant trees.

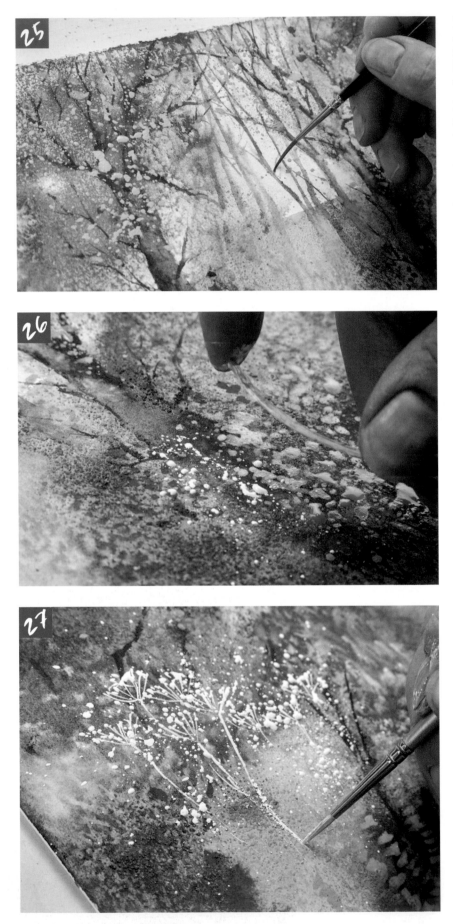

25 Add a few branches to these distant trees. Don't make these too bold; you want them to fade into the background to create the illusion of depth and distance.

26 Use the small palette knife to spatter some white ink here and there to suggest cow parsley.

27 Connect a few of the white ink dots together with the rigger and white ink to suggest florets, then change to the size 2 round brush to draw the main stem away downwards. Continue to adjust and refine the shapes across the painting until you are happy with how it looks.

The finished painting.

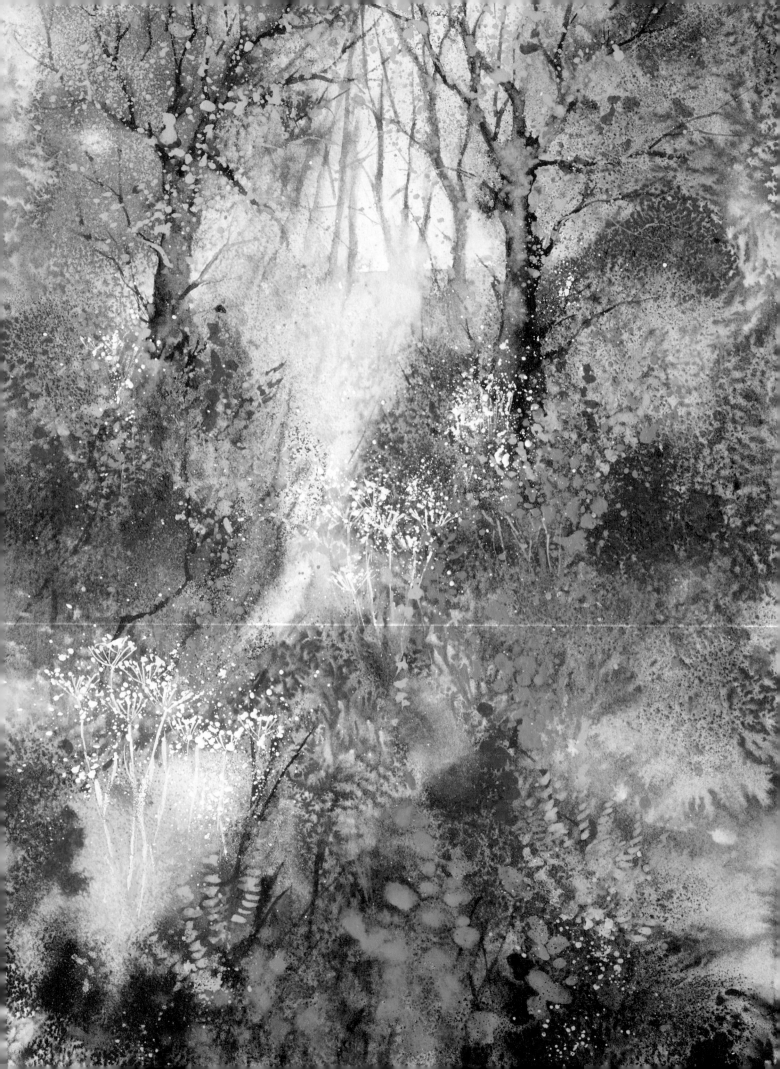

FOOD WRAP

This is a simple and effective technique that will help to give your work a new dimension. Simply by placing plastic food wrap on top of wet paint; interesting markings and shapes can be formed where the plastic touches the paint. Inks and granulation medium can also be added once the wrap is on the paper with the use of a pipette – simply make a small hole in the wrap and poke the tip through. This adds even more interest as the liquids wind their way through the channels made by the wrap.

When the paint is completely dry (this takes a little longer than usual, because the plastic prevents air reaching the paint; so leave it for at least a couple of hours or ideally overnight) the wrap can simply be peeled away to reveal the pattern it has created. You can, of course, simply leave it as it is, but you can also develop the shapes into different subjects. Sometimes, an idea for a painting will jump out immediately as what you reveal provides a spark of inspiration.

Using plastic food wrap

The effects of the plastic wrap are more intense if placed on a wet on dry wash. However, I prefer to use a wet-in-wet wash, enabling colours to mix and merge together on the paper, before adding the plastic covering. The marks the wrap leaves can be controlled to a certain extent. For example, once it's on the wet surface, you can pull the food wrap into creases to make linear markings or scrunch it up to make a more busy pattern. It can be used to cover the whole of the painting or just certain areas, such as leaves or petals for instance, where the marks will help define their form.

1 Lay plastic food wrap loosely onto wet paint, so that it falls into interesting patterns.

2 You can stretch the plastic food wrap slightly to suggest stems or lines in certain directions.

3 Leave to dry thoroughly, then peel it away to reveal the effect.

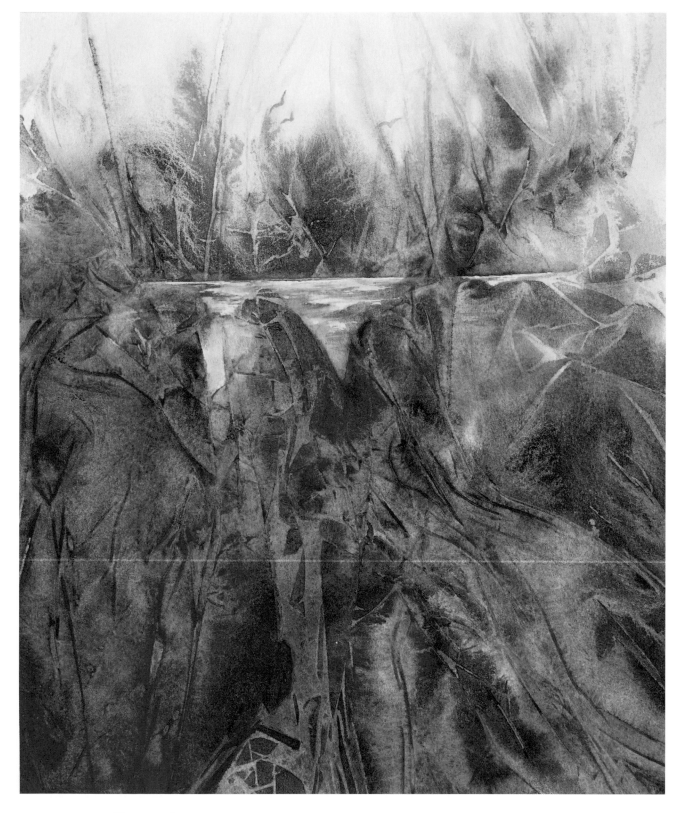

Irises at the Lake

Peeling back the wrap to reveal the beautiful patterns is an exciting stage. When
I removed the plastic wrap from this painting, I could see the shape, patterns and
colours of irises with distant foliage as though they surrounded a lake. All I needed to
do was to add a little white gouache to bring out the water and then leave it.

Painting
Cornflowers

The textures, created
using a combination
of skeleton leaves and
plastic food wrap,
contrast with the delicacy
of the cornflower and
allium blooms.

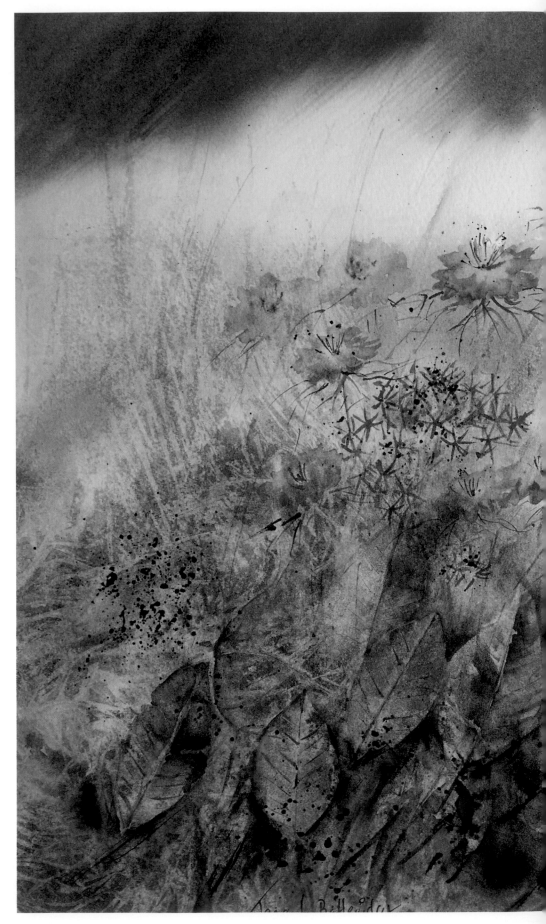

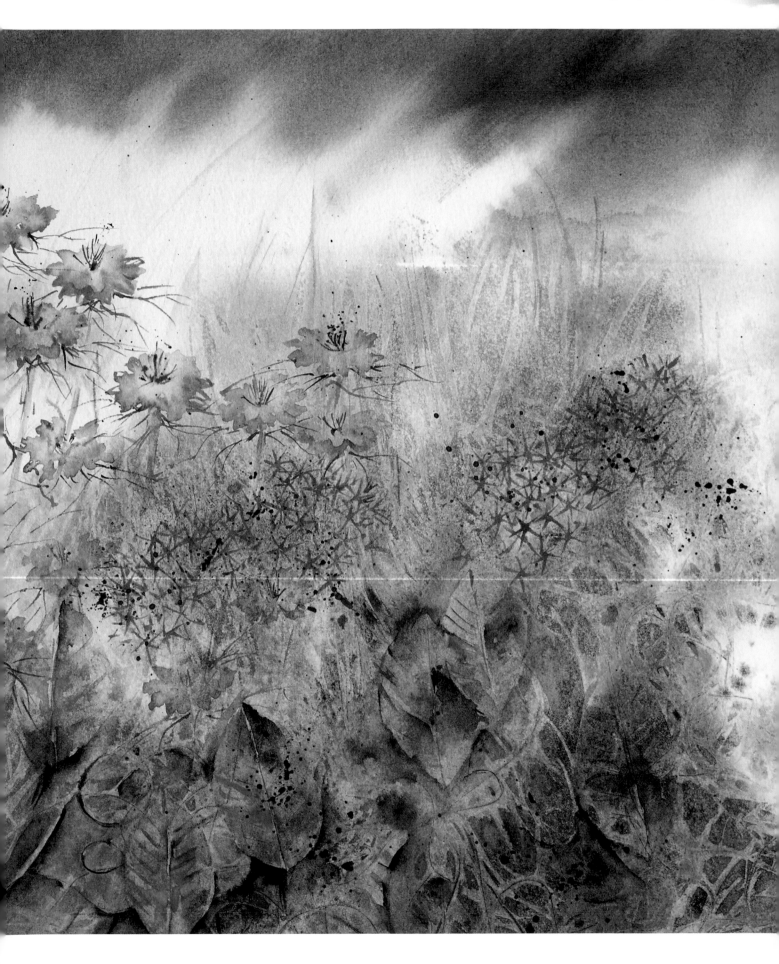

SALT

If you are a traditional watercolourist, and reluctant to try new approaches to your work, the application of a sprinkling of salt might tempt you. It requires little effort to achieve big results. Salt is ideal for use in skies, seascapes, landscapes and flower painting. It can give textural results as well as adding sparkle and interest.

After applying pigment to wet or dry paper, the salt should be added just as the paint is starting to dry and lose its shine. Once the salt hits the paint, it pushes the pigment away to leave unusual markings.

Table salt works really well to give smaller markings whilst rock salt, which has larger, coarser granules, does the same but with exaggerated effect. If you are after a subtle effect, try sprinkling fine salt sparingly. A more random, dramatic effect can be achieved by adding generous amounts of the rock salt.

When using larger granules, spraying the paper after application with a little water will also encourage more mottling and intensify the effects. Note, however, that spraying water into finer salt on the surface can result in the loss of their subtle effects; as the water washes all the salt away.

Salt residue must be brushed away after the paint has completely dried.

Sprinkling salt

The same results can never be replicated, so each piece of work you do will be different because of the techniques's unpredictable nature. Be aware that if your timing hasn't been quite right – your paint too wet or too dry – you may be disappointed; so try again. You'll soon get the hang of it.

1 For larger grains of rock salt to dissolve, the surface must be quite wet, so be sure to pre-wet your surface before painting.

2 While the paint is still wet, pour more salt than you will need into your hand, and use your other hand to sprinkle it directly into the wet paint on the surface.

3 To encourage the large grains of salt to dissolve, use a water spray to lightly wet them. If you look closely, you should be able to see 'halos' around the grains as they absorb some of the water.

4 Add smaller grains of table salt slightly later. The paint should still be wet.

5 Once completely dry, you can simply brush the salt residue away, to reveal the effect.

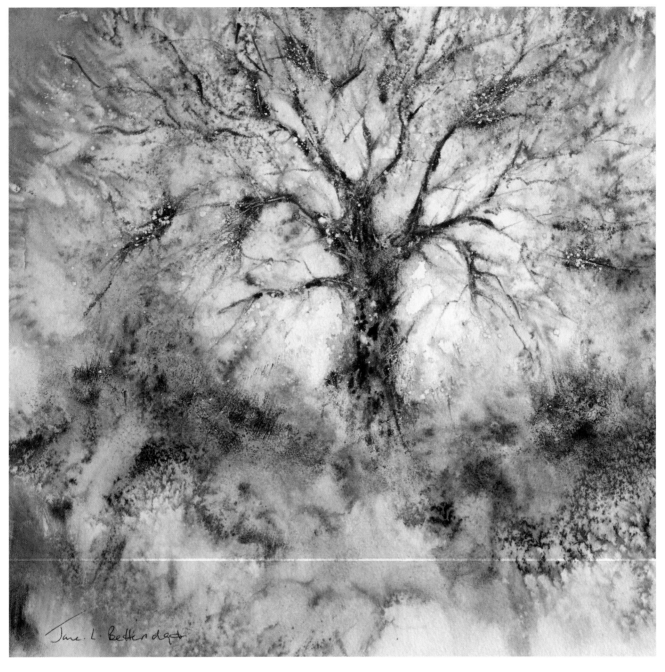

The King of the Forest

I really enjoy using this easy, effective medium in my work. While I know generally what the results will be, it is impossible to control completely, so waiting for the results as the painting dries is quite exciting.

Both fine and coarse grains of salt were added to a wet-in-wet wash of indigo paint and sepia acrylic ink. I sprayed it here and there with a little water as it started to dry. Once the paint was completely dry, and the salt had been brushed off, the tree trunk was added using more of the ink with some granulation medium. When I'd finished working back into this painting I could see a stag's head in the tree trunk with the branches suggesting antlers – hence its title.

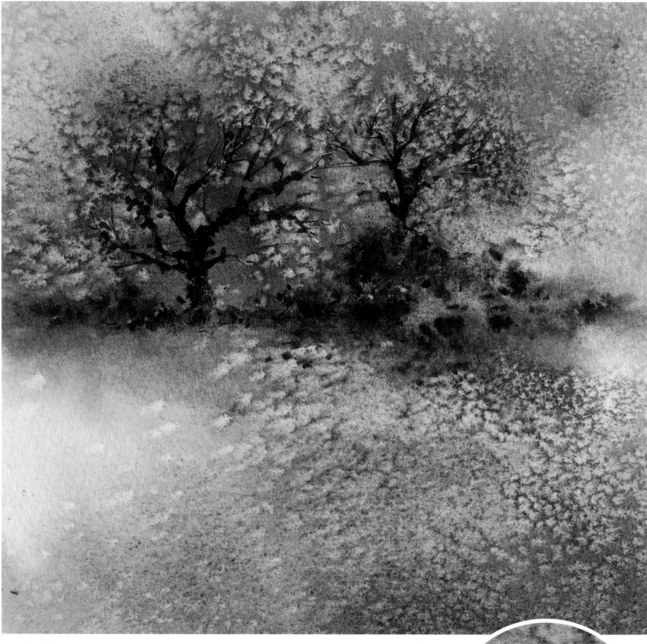

Painting *Golden Landscape*

After laying in a wet-in-wet wash of French ultramarine blue, cobalt turquoise light and burnt sienna, I added fine-grained table salt just as the paint was losing its shine. When it was dry, the marks it made reminded me of autumn leaves so I added some trees and foliage by mixing the French ultramarine and burnt sienna together.

The marks left by table salt are typically small and subtle – useful for less dramatic, more atmospheric effects.

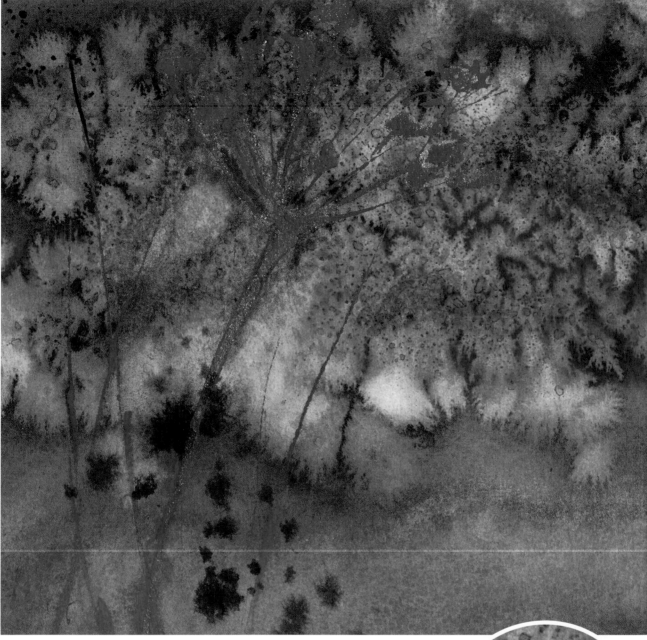

Painting *Dancing Weed*

A variegated wash of brilliant orange, opera rose and cobalt turquoise light provided the base of this lively, vibrant background. The addition of coarse-grained rock salt added a lot of striking texture and interest.

When it was dry and the salt brushed away, I painted an outline of some cow parsley in turquoise acrylic ink and also added a little aqua shine to make it sparkle.

The coarser grains of rock salt leave bolder and more striking marks than table salt: perfect for more impact.

GOUACHE

I often use gouache when painting. It is very similar to watercolour, but is opaque, which enables the artist to paint light over dark – an effect otherwise impossible in watercolour. One of my favourite techniques is to create a really interesting watercolour background, letting the colours mix and mingle on the paper – in a way no other medium does – and then, when dry, painting over the top with colours from my palette of gouache paints.

Because it is so similar, gouache can be prepared and used in much the same way as watercolour. It will interact in a similar way with media like inks, along with the other materials and techniques in this book.

Using gouache

Prepare gouache in a separate well to your watercolours in order to keep colours clean.

1 For the coverage needed to paint light over dark, add only a little water to the paint when preparing it, so that the gouache is relatively stiff.

2 Using a dry brush will allow you to create this interesting slightly broken effect over a dark background.

3 For greater coverage, simply use more paint on the brush.

White Hydrangea

I used white gouache on top of a mixture of watercolours and inks, to paint this suggestion of an hydrangea.

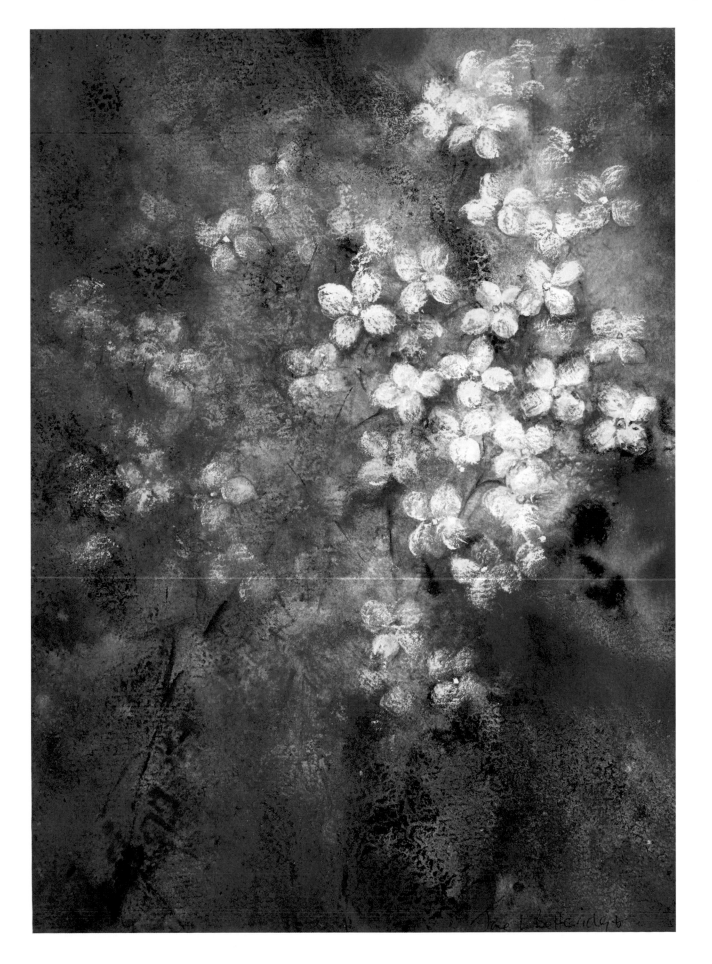

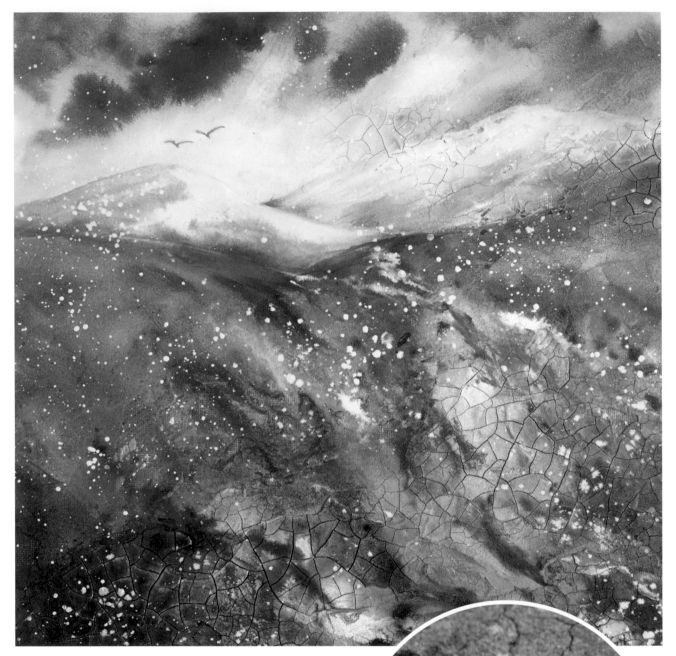

Painting *Pink Lava*

I used white gouache mixed with opera rose watercolour to achieve a vibrant, intense pink in this mountainous scene. White gouache was added to create eye-catching highlights both when the watercolour was wet – for the softer effect visible on the lower right-hand corner – and when the paint had dried, as shown in the inset detail.

Sufficiently watered-down, gouache can be spattered like watercolour paint or ink. If you get the consistency right, it will retain its power to cover darker colours.

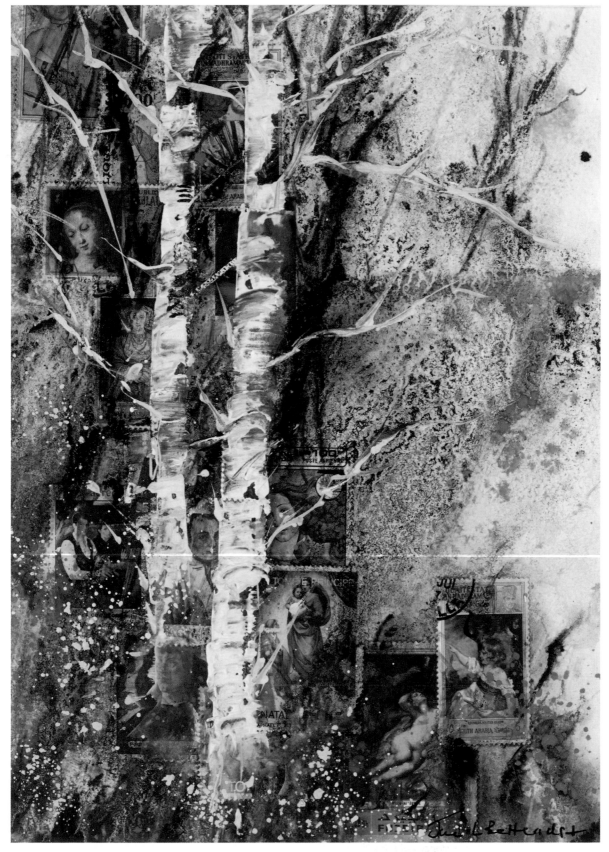

Painting *Mystical Forest*

White gouache, applied with a palette knife dragged sideways, was used
to suggest the silver birch trees on top of a collage and ink background.

CONTOUR RELIEF

I'm always looking for new materials to use in my work. I first used contour gel as an outline in some silk paintings I did years ago, and later realized it would be a very useful medium to add to my watercolours. It leaves raised marks that can enhance your paintings and make them look three-dimensional. I find it especially useful for foreground work and also stamens in flowers.

Using contour relief

Supplied in a tube with a long nozzle – ideal for its application – contour relief gel is available in various colours, including metallics. Contour relief gel can be used straight from the tube; simply squeeze it while you draw the nib of the tube along. The only things to bear in mind are that it must be used on a dry surface, and it takes at least two hours to dry. You can paint over the top of it or, as shown here, you can use it on top of dry watercolour.

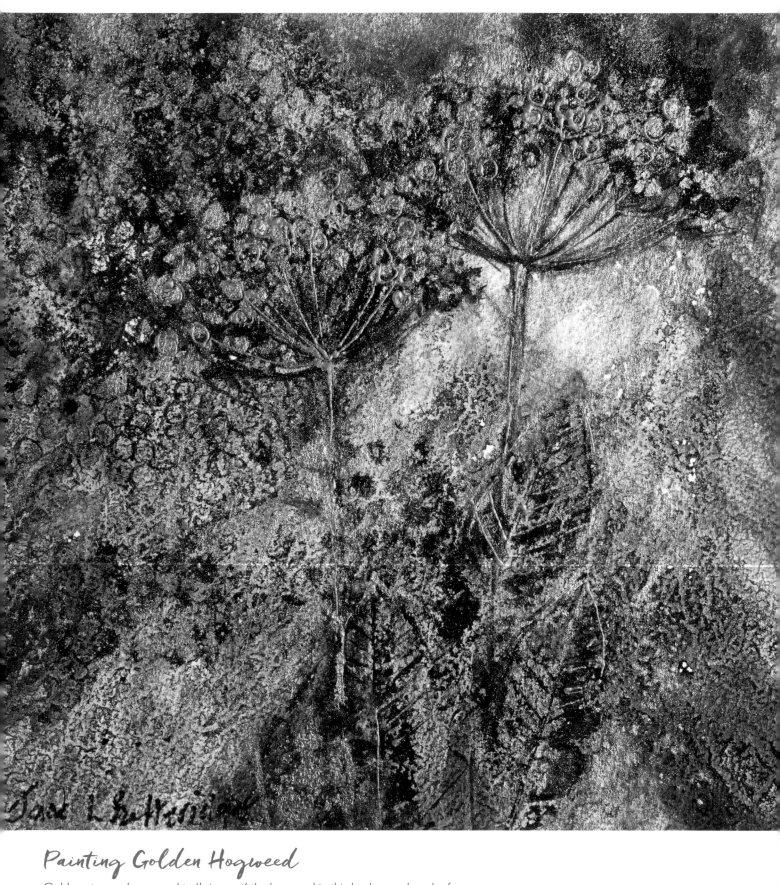

Painting Golden Hogweed

Gold contour gel was used to 'bring out' the hogweed in this background wash of sepia and black ink and gold bronzing powder

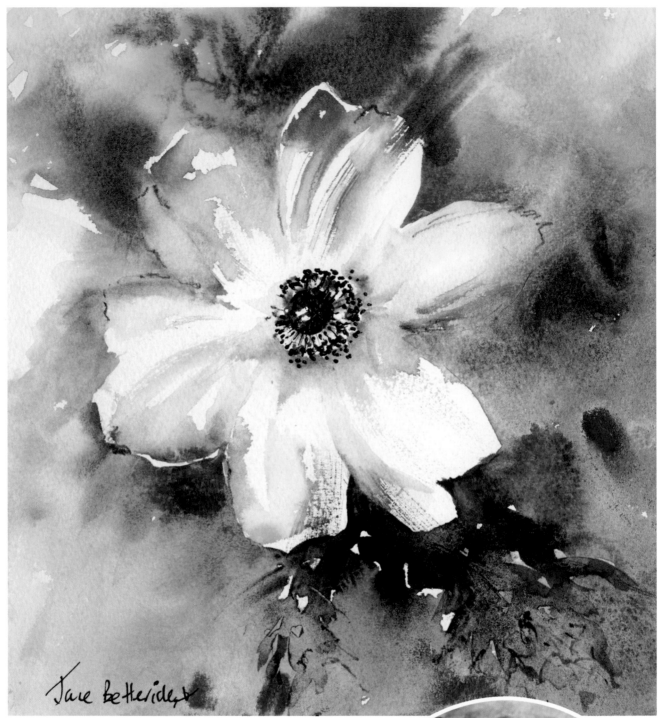

Jane Betteridge

Painting *White Anemone*

I used black contour gel to paint in the stamens in the centre of this flower painting. It really makes them look three-dimensional.

All contour gels have a glossy finish, really enhancing the three-dimensional effect you can achieve.

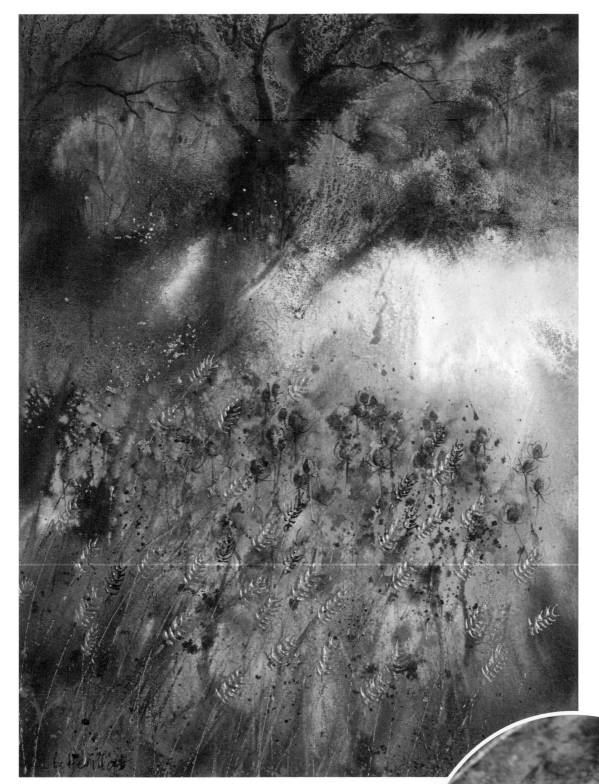

Painting *Ripened Corn*

A watercolour wash with added inks and granulation medium was used in the background of this cornfield. I then painted in the teasels and used gold and copper contour gel to suggest the ears of corn.

The contour gel makes the ears of corn really stand out when the light catches them.

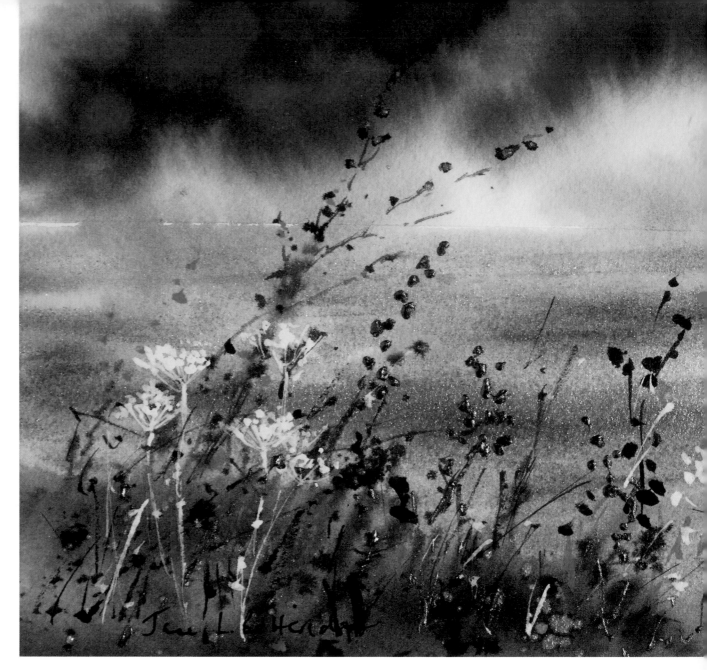

PEARLESCENCE

Subtle – or even a little more obvious – sparkle in watercolour can be engineered with a little help from pearlescent mediums. I like to use Schminke's aqua shine, which is specifically designed for use with watercolours. It comes in a bottle and is quite thick and opaque looking. It can be painted neat on top of dried watercolours and inks or added to paint whilst it is being mixed with water for a softer effect. The opacity seems disappear once dry. Ideal for water, skies, flowers, fish and birds.

Pearlescent mediums can be mixed with paint, or applied straight out of the bottle – in the latter case; simply paint it on using a brush. Once dry, the medium gives a shimmering effect when it catches the light.

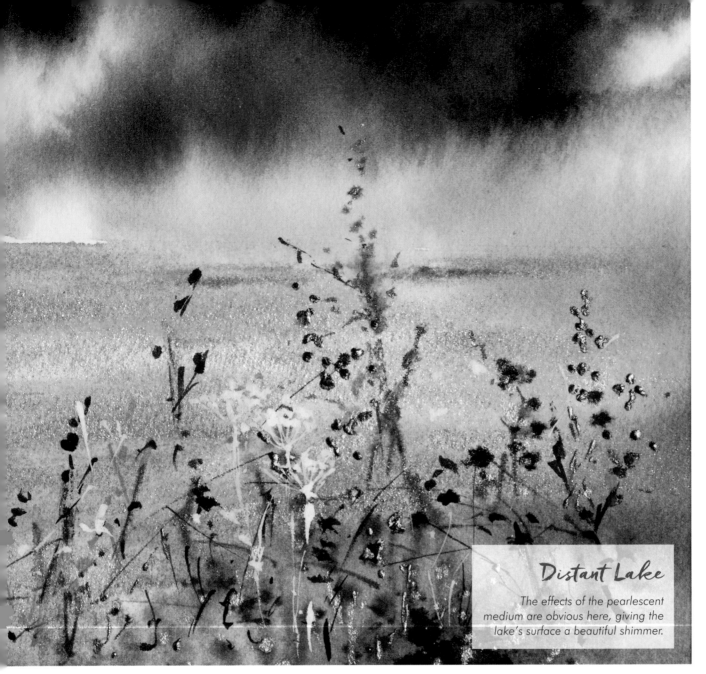

Distant Lake

The effects of the pearlescent medium are obvious here, giving the lake's surface a beautiful shimmer.

Mixing pearlescent medium with paint

As shown opposite, you can use these mediums to paint directly, but you can also mix them into paint beforehand.

1 Pick up some medium on a clean brush and deposit it into a well of prepared watercolour (see page 14).

2 Use the brush to thoroughly mix the medium and paint together.

3 You can now use the mix exactly as a normal watercolour. The finished result is more subtle than when the medium is used directly on top of dry paint.

IMPASTO

Thickening mediums are gel-like substances that can be added to watercolour paints for an impasto effect. It can be useful for textural effects or to use your paints in a similar fashion to acrylics or oils.

I use Schmincke's aqua pasto because it is neutral in colour and, unlike some other thickening mediums I have tried, doesn't seem to alter the vibrancy of the watercolour. I find the best way to mix paints with thickening medium is by using a palette knife to blend the two together; you can then use the same knife to apply the mixture to the paper or canvas.

Preparing and using thickening medium

Most paint prepared with thickening medium will dry slightly glossy.

1 Squeeze the paint into a palette well.

2 Use a palette knife to scoop out roughly twice the amount of thickening medium as paint.

3 Using the palette knife, start to mix the paint with the medium.

4 Continue to mix the two together until they are thoroughly combined.

5 Apply to the surface using the palette knife. You can suggest shapes and patterns using the knife to shape the prepared mix on the surface.

Try applying the thickening medium in different ways for different textural results.

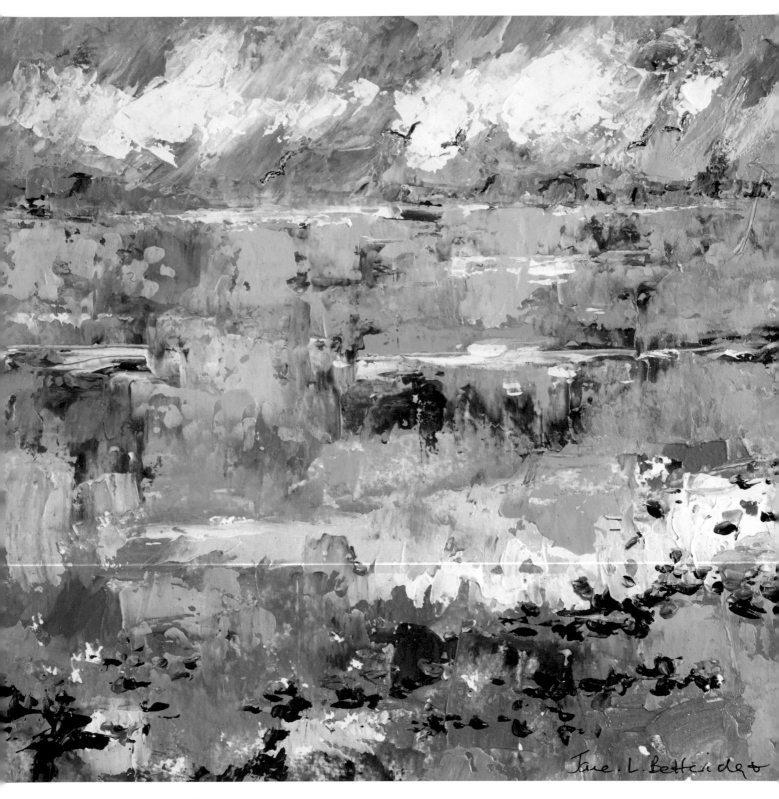

Impressionistic Seascape

I used watercolours, in various shades of blue, turquoise and natural ochre, mixed with aqua pasto to allow me to use impasto techniques to create this impressionistic seascape.

BRONZING POWDER

These sparkly luxurious metallic powders are wonderful, a real must-have in your kit. They come in various shades of silver and gold and also a bronze colour too. When prepared, by being mixed with water, they always remind me of molten lava erupting from a volcano. Bronzing powders can be prepared very thinly to give a hint of sparkle or to the consistency of single cream for excellent coverage – the latter is usually the approach I take.

I love to see them spattered in a background or used to emphasize the light catching leaves on trees or birds' wings. The gold is really good to use when painting autumn leaves. They can be used on top of inks as well as paint and sprayed with a touch of water for a more subtle effect.

Preparing and using bronzing powder

1 Scoop a little bronzing powder out of the pot and place it into a small dry container. An old bottle top is perfect for the small amounts you will typically use in a single painting.

2 Use a pipette to add clean water, diluting it down exactly as though preparing paint.

3 Stir the powder into the water using an old brush, until it is at a creamy consistency.

4 You can now use this like any other paint, applying it with your usual brushes.

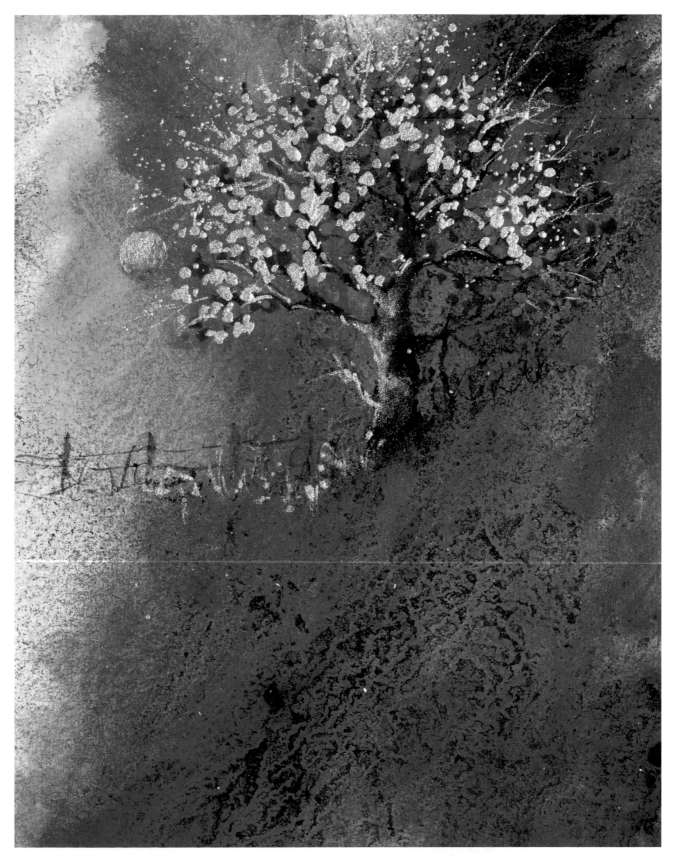

Tree on the Hill

I used the silver bronzing powder over the top of the dark tree in this painting.
The background wash combined paint and ink.

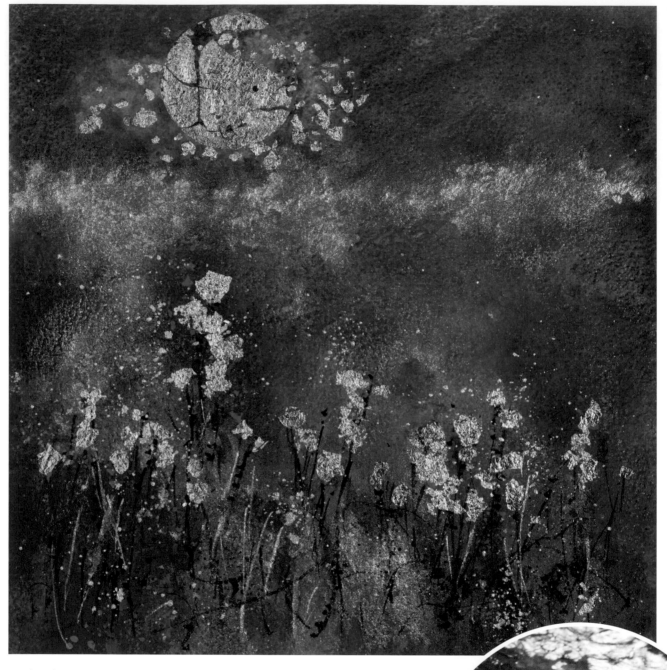

Painting *Eastern Sunset*

This dramatic sunset was painted using brilliant orange and opera rose watercolour paints. Whilst the wash was still damp, I added a distant horizon line by dropping in prepared gold bronzing powder. I also added some flecks here and there in the foreground.

I added the sun and the suggestion of foreground foliage using gold leaf. The bronzing powder was the perfect complement – its natural softness and blendability contrasted with the harsh edges left by the gold leaf. Two metallic media, different in their properties.

Different metallic media – such as the gold leaf and gold bronzing powder used here – tend to work well together.

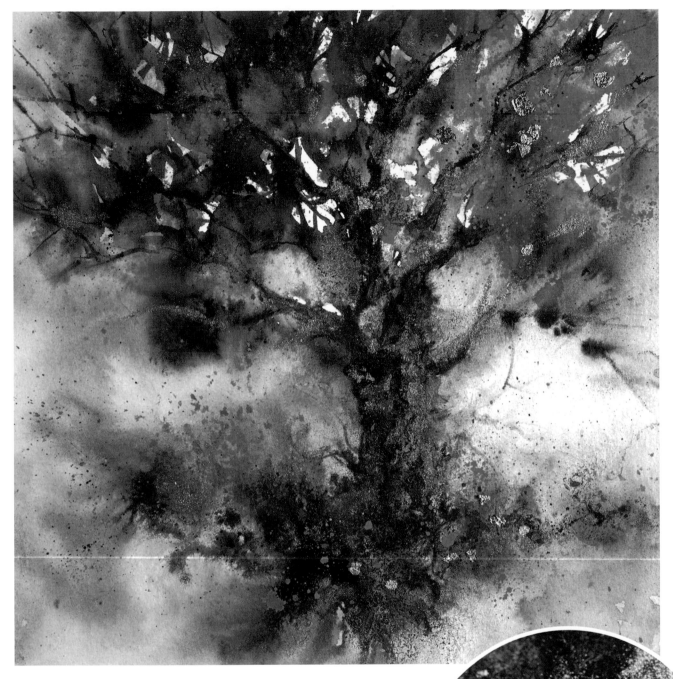

Painting *Autumn Tree*

This tree was painted using lovely rich autumnal colours: quinacridone violet, Indian yellow and touches of opera pink. I used sepia acrylic ink with granulation medium for the tree and, while this was still wet, I dribbled some of the bronze shade of bronzing powder into the ink, encouraging it to move and flow around. When the painting was completely dry, a few bronze gilding flakes were added and secured with adhesive, making it look as though the odd leaf were catching the light.

The contrast between the reflective gold and the dark ink gives this painting great impact.

STENCILS

Patterns, numbers, text... virtually any subjects can be added to your work with the help of stencils. There are lots of commercial varieties to buy, or you can use found objects. Most commercially manufactured stencils are made from plastic, but I also make my own from card or paper or use organic, natural materials such as leaves. You can find materials ready to use as stencils in surprising places; one of my favourites is a wrapping paper used by a local florist, which is covered in tiny leaf shapes – very useful!

I find some of the patterned stencils most useful if there's an area in a painting that you think needs a little something, but nothing too definite. A few patterned stencil markings can solve that problem. The painting on page 143, *Teasel Textures*, is an example of the use of stencils. I used a commercial stencil to add understated marks in dark watercolour and to suggest stems in gold bronzing powder.

Using stencils

Lay the stencil over your dry painting, and simply paint through the holes. To avoid the risk of the paint creeping under the edges of the stencil and spoiling the effect, it is best to use thicker paint: either watercolour at a very creamy (almost neat) consistency, or gouache.

Cut-out stencils like those shown here will result in positive shapes. Negative shapes can be made by either placing a cut-out shape or object on your surface and painting around it, leaving the shape inside the marks.

Mossy Green

After painting a background using paint, ink and granulation medium, I used the stencil from my florists' wrapping paper to paint in the lime green bush.

GAUZE & THREAD

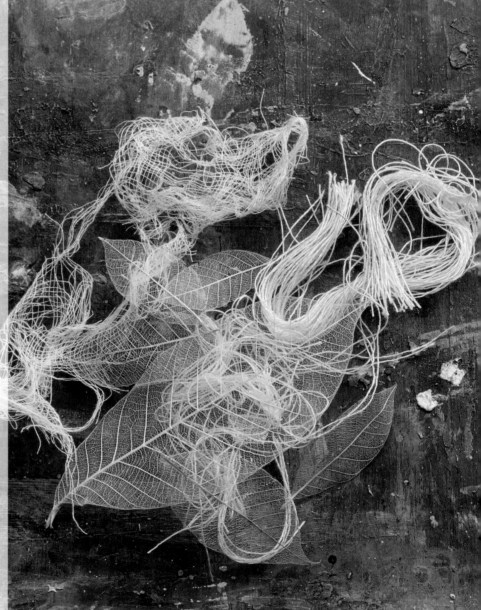

To add extra texture-making marks to my work, I often introduce cotton thread and gauze (old-fashioned cotton bandage) to replicate branches and tangled hedges, ditches and interesting foliage.

I usually distress the gauze, pulling sections of it apart. You can either place these on the paper (adding a little water with a brush will help keep it in position) before you add any paint, or you can put the paint on first and then place the gauze on top.

The same applications can be made with single strands of cotton thread and commercially bought skeleton leaves. Skeleton leaves are really useful – you can use them as a stencil, drop them into wet paint or, after putting some quite thick paint on one, you can stamp their markings in areas that need some added interest.

Any of the items can be placed into wet paint in your palette and then stamped onto a dried wash. You can use a spray bottle to blend the results in a little if they appear too overpowering.

Gauze, thread and skeleton leaves can also create lovely shapes and patterns if used alongside plastic wrap; they should be positioned onto the wet wash before the wrap is added in the normal way.

Using gauze and thread

1 Lay the material – gauze, in this example – directly into the wet paint. Press down firmly with your fingers; don't worry about leaving fingerprints.

2 You can build up multiple layers using these textural materials. Here I have added skeleton leaves.

3 Try using the dropper connected to the top of the ink bottle to drop ink into the materials. They will soak it up and draw it along, which gives a fantastic finished effect.

4 Adding additional paint over and around the materials will make the eventual result clearer. Use your brush to press down the material and encourage it to soak up the wet paint, then allow to dry thoroughly.

5 Peel away to reveal the effect.

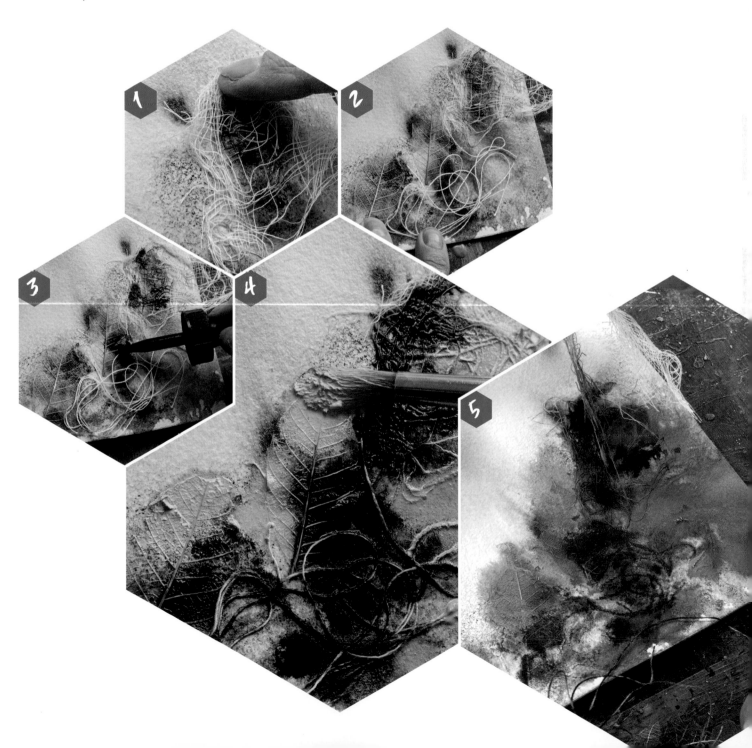

Painting *Atmospheric Hedgerow*

This painting has an unusual colour scheme – shell pink and jaune brilliant. These hues give a murky, ethereal take on an otherwise traditional scene of the tangled undergrowth in a hedgerow. Using colour not normally associated with a particular subject makes your work a lot more interesting.

I added shredded gauze, skeleton leaves, indigo ink and granulation medium to the initial background watercolour wash. The technique is shown in more detail on the previous page. I peeled off the materials when dry and added some distant cow parsley.

Ink

I used more watery indigo ink to paint the distant cow parsley. Softer edges help to push it back visually.

Creating texture

Here you can see how the gauze helps to create marks that suggest branches, twigs and undergrowth; perfect for adding interest.

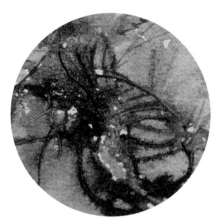

Ink flow

The effects of the ink running up the thread are clearly visible here. This is very useful for suggesting stems and other vegetation

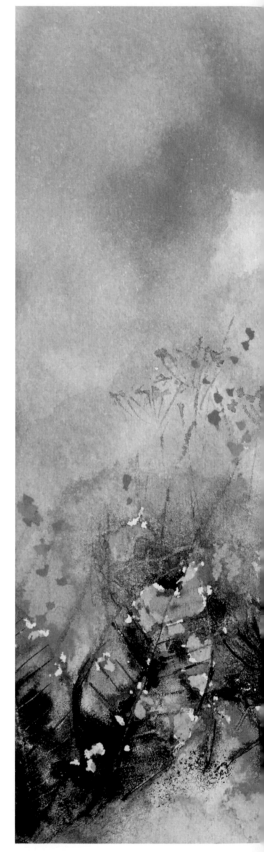

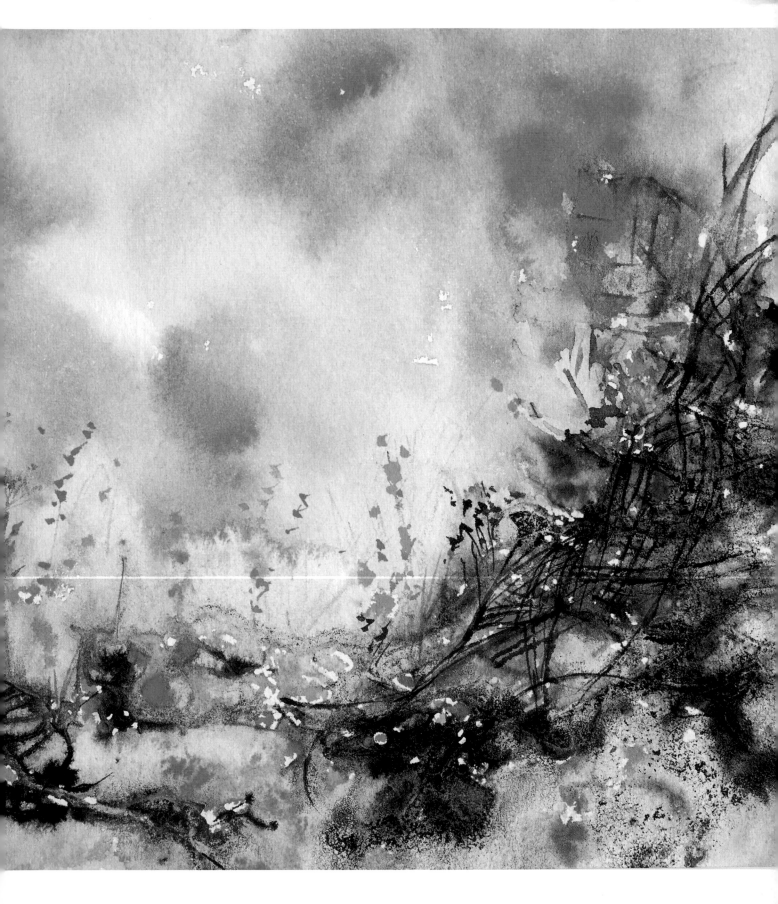

Wild Flowers in the Wood

Catching a glimpse of sunlight highlighting these textured tree trunks gave me the idea of how to try and emulate the three-dimensional effect I witnessed. This project gives you the opportunity to combine many of the techniques from the rest of the book.

1 Squeeze a generous amount of fine watercolour ground onto the canvas board. Use the bristle brush to work it into the surface, covering it evenly right to the edges.

2 Start placing the watercolour strips into the wet ground, all ending at the top of the board. These will form the trees later on, so take your time arranging them.

3 Paint over the strips with more of the watercolour ground (you will likely be able to use what remains on the brush.)

4 Crumple up the tissue paper, then unfurl it and lay it on top of the board, overlapping all of the edges. Don't stretch it out – you want to retain the wrinkles.

5 Put more of the fine ground in a mixing pot and water it down to the consistency of single cream. Carefully paint the watered-down ground over the whole surface using the bristle brush. Don't be too vigorous, as you can tear the tissue paper.

6 Allow the ground to dry overnight. You can tear or trim off excess tissue past the edges of the board.

TIP

Trim the corners from your watercolour strips before applying them to the surface. This helps them to look more natural, and reduces the risk of tearing the tissue paper later.

7 Prepare verditer blue and leaf green paints to a single cream consistency. Use a size 10 brush to add some verditer blue into the top of the sky, aiming for a broken effect, with gaps of clean white space.

8 Rinse the brush and blend the paper downwards a little way. Use the same brush to apply more verditer blue to the left-hand sides of the trees.

9 Protect your painting surface with some kitchen paper at the bottom of the board. Touch in leaf green over the midground and background, again leaving some white spaces. Avoid the trees, but don't worry too much if a little green spills over.

10 Use a wet brush to blend the paint in a little, and use a clean piece of kitchen paper to lift out a little paint and vary the tone.

11 Wet the foreground with clean water and the size 16 round brush, then touch in indigo ink using the dropper with a scribbling motion.

12 Use the pipette to add granulation medium over the ink.

13 Tip and tilt the board to encourage the granulation medium to move the ink around.

14 While the indigo ink is still wet, add olive green ink. Again, add granulation medium into the new areas of ink, then tip and tilt the board.

15 Set the painting down flat and use a clean wet brush to lift out a little ink and brighten the tone here and there, particularly around the edges.

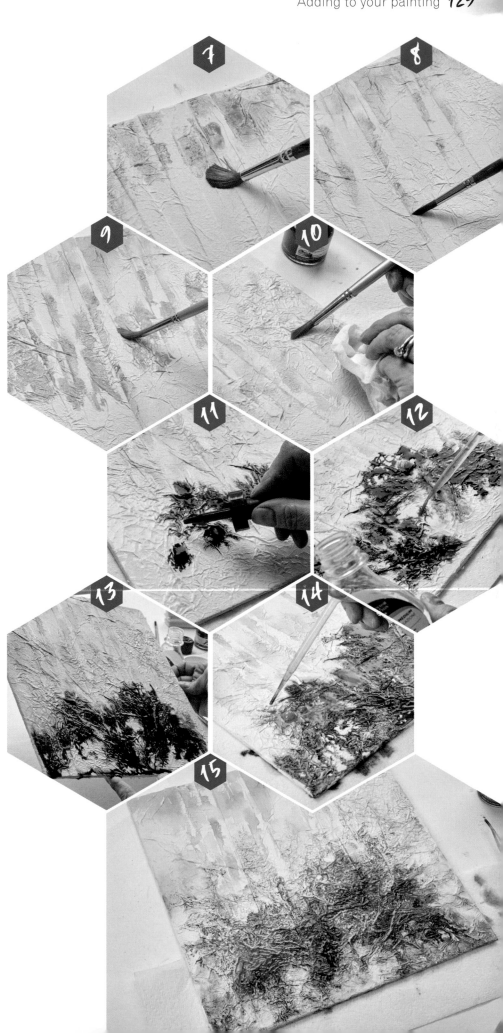

16 Prepare Vandyke brown to a single cream consistency, then combine this with the verditer blue to make a grey mix. Use a size 6 round brush to add the suggestion of some distant tree trunks with this mix.

17 Switch to the rigger to add some fine branches to the tree trunks. Add a few coming downwards, from out of frame.

18 Use Vandyke brown on its own to add a few touches here and there on the main tree trunks with the size 6 round brush. Favour the left-hand sides of the tree trunks to suggest that the light is coming from the right-hand side.

19 Use the size 12 flat brush to draw the colour from the shaded side to the other side, creating the distinctive texture of the silver birches.

20 Use the rigger to pick out creases on the paper that suggest branches. Don't have them all extending from the sides of the trees; add some branches that come out from on top of the trunk too.

21 Suggest some saplings and general undergrowth around the bases of the main trees, painting it in the same way as the main branches. Develop the undergrowth and branches by adding some with verditer blue too.

22 Prepare jaune brilliant to a creamy consistency, then pick it up on a size 10 round brush. Wipe away most of the paint from the heel of the brush (see inset), then lightly graze the brush over the surface at the top of the painting, picking up the topmost part of the tissue paper texture.

23 Use a small palette knife to spatter some of the jaune brilliant here and there over the painting; mostly over the top.

24 Add some touches of leaf green to the main tree trunks with the size 10 round brush, then spatter some more over the bases of both the main and background trees.

25 Dampen the angled brush and draw the blade of it upwards to lift out the suggestion of a light-toned tree in the distance.

26 To add some lighter tones in the foreground, use the size 6 round brush to add some leaf green touches. Use the tip to add bolder shapes, and graze the side over the surface to pick out the raised parts of the tissue paper. Do the same with the jaune brilliant, but restrict this to a few hints here and there.

27 Use the size 2 round brush and titanium opaque white to add a few touches here and there as cow parsley florets.

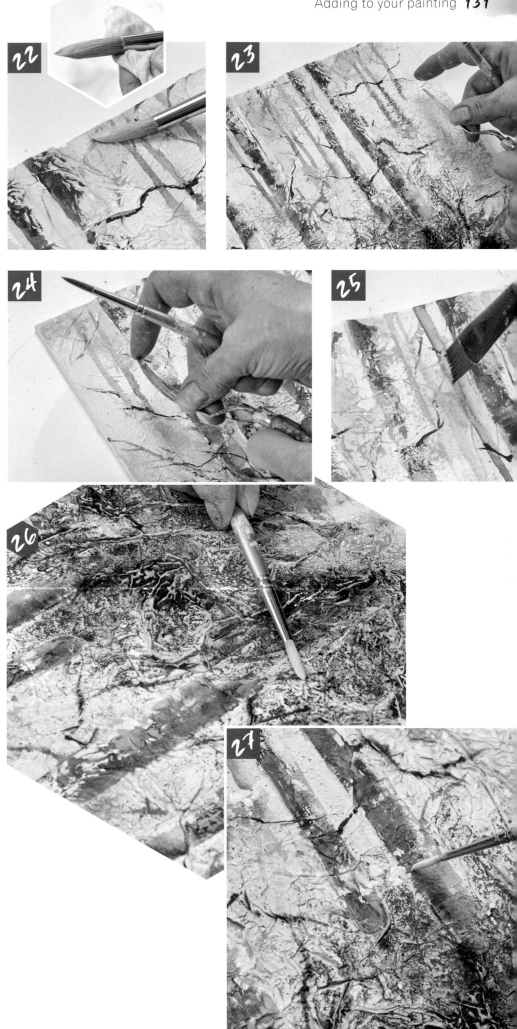

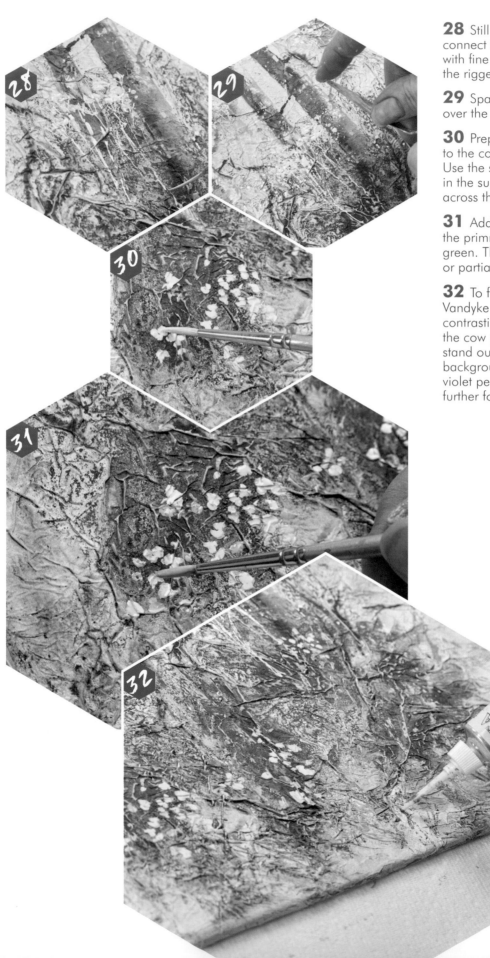

28 Still using the white paint, connect the florets and add stems with fine lines applied using the rigger.

29 Spatter some white acrylic ink over the areas of cow parsley.

30 Prepare some cadmium lemon to the consistency of single cream. Use the size 2 round brush to touch in the suggestion of a few primroses across the woodland floor.

31 Add some similar shapes near the primrose clusters, using leaf green. This suggests some in shade, or partially hidden.

32 To finish, use the rigger with Vandyke brown to add some contrasting dark touches between the cow parsley stems, to help them stand out against the tree trunks and background foliage, then use the violet pearl contour gel to add some further foreground flowers.

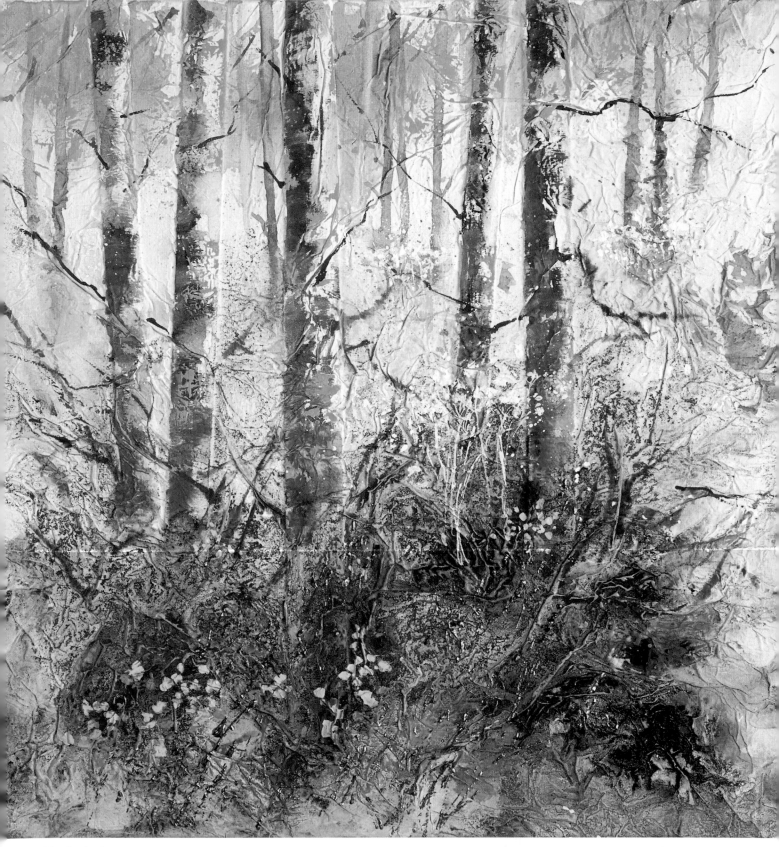

The finished painting.

IDEAS AND INSPIRATION

By now, you have learned all the practical techniques for expanding the way you work with watercolour. This part of the book is intended to show you a few examples of what you can use these techniques for; and how to look beyond individual paintings. I hope it provides you with inspiration for your own works.

EXPLORING THEMES

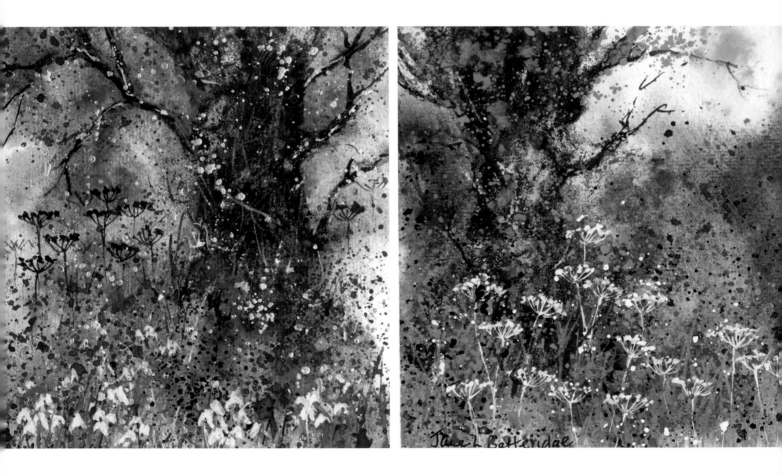

Finding a theme

Put simply, a theme is an idea or subject that appears in multiple paintings. Depending on your interests, there are many themes you could explore. A favourite painting or scene could be painted in many different ways, for example. This could be done by simply changing the colour or materials you use. Play on the same theme by using collage instead of just paint to see what results you can get; or placing the main focal point in a different position.

Any subject, or subjects – boats, buildings, cars, people, animals, flowers, as just a few examples – can lead to a themed set of paintings by altering the surroundings. Alternatively, the surroundings themselves could stay the same, while the subject changes: the key point is that a group of paintings shares some unifying element or mood.

Changing Seasons

Left to right: Winter, Spring, Summer, Autumn.

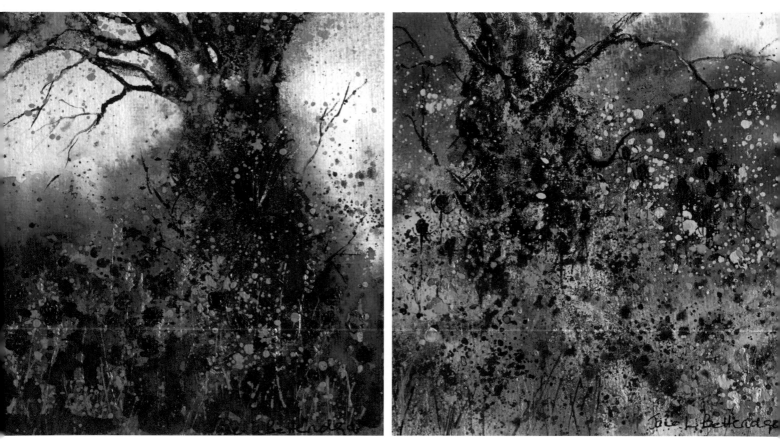

Theme: changing seasons

My themes always revolve around the natural world. In this series of paintings, the theme is the changing seasons: from the cold, stark, depths of winter with its blues and greys, silvers and dried up remnants of the preceding seasons; through to spring, with its new shoots, snowdrops, bluebells, camellias, daffodils and tulips – new horizons and anticipation for the year ahead. The warm balmy sunny days of summer, heat rising up from the pavement, colours reflecting from the abundance of flowers and plants and insects busy buzzing around doing their thing. The autumn, with its ochres, oranges, golds and dried seed pods; honesty suddenly becoming noticeable because of its shiny silver heads and teasels changing from mauve to pale gold and then umber. The leaves crunching underfoot, the corn in the fields waiting to be harvested and the beginning of the darker nights... Just writing these words makes me want to paint. No matter the time of year, I'm never at a loss as to what subject to embark upon.

FOCUS

There is so much to paint in the natural world that sometimes there is too much choice; it can feel overwhelming and we end up not painting anything. In these cases, it can be helpful to find a tighter focus, and concentrate on a single detail. You can then build and expand on this as you feel less overwhelmed and more comfortable.

Whether you are visiting somewhere new and interesting, or simply sitting in a familiar space, take a few moments to have a good look around, breathe in the smells and listen for the sounds around you. Then, paint what you feel. You could start by mixing the colours that have inspired you and playing with the paint; or by picking up a simple object such as a feather, pebble or leaf, and taking a really good look at them before starting to paint. Look for surrounding shapes and marks; add other found objects and new colours to your work; expand your markings.

Starting from a narrow focus will help to reawaken your appetite for painting; you will soon find yourself expanding your scope and exploring again.

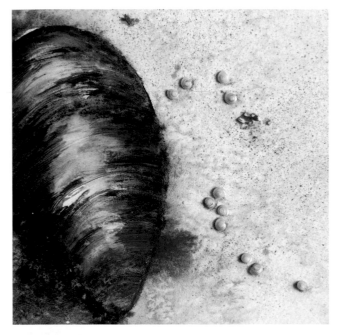

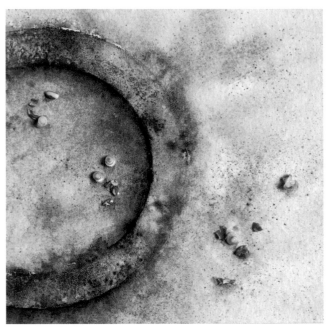

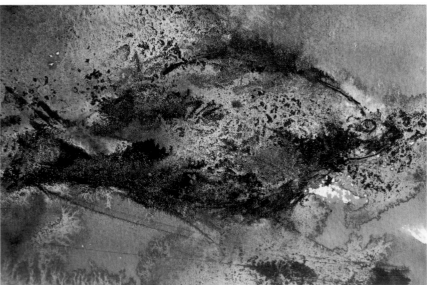

Coastal textures

The coast is an endless source of inspiration to me. A rusty metal ring on a fisherman's boat, with its decaying, eaten-away surface patina; old lobster baskets; dirty, weather-beaten old buoys; shells; fish skeletons; pebbles; sand patterns and the sea are all favourite subjects of mine.

Their rustic, weathered, surface characteristics influence the other subjects that I paint too: they have made an impression on my subconscious which seems to come out when painting a completely unrelated topic.

Focus: texture

Texture in the natural world, or texture created by the natural world, is what I seem to favour focusing upon in my paintings. I came across many of the materials and mediums that I have covered in this book by looking for ways to express texture visually; these materials and techniques help me to paint what certain subjects arouse in me.

The examples on these pages show two sets of paintings. Each group shares a theme, but running through all of them is a common focus on texture.

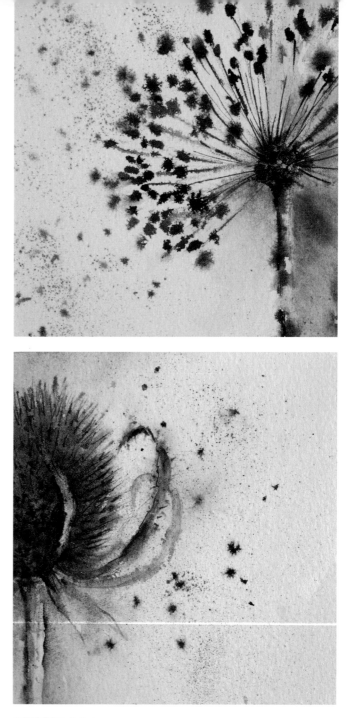

Organic textures

I never, ever, tire of the natural textures of organic matter such as dried seed heads, grasses, pods, teasels and so forth. Their skeletal shapes with rough, smooth or raised markings, unusual colours, brittle stems, scraggy appearance and dried, scrunched-up, decaying leaves, all fragmented from the elements, blowing about in the breeze, clinging on for dear life; they just draw me in more than anything else.

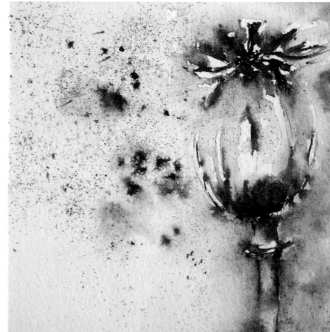

PATTERN & COLOUR

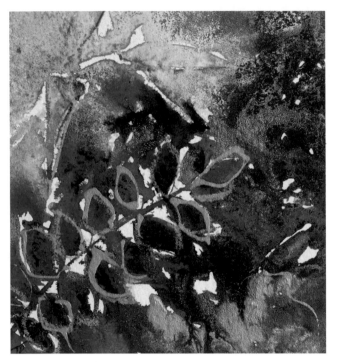

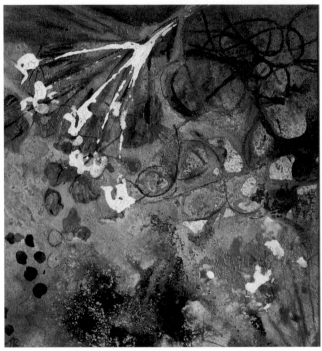

Soft natural forms

Playing with paint, using non-traditional colours, making marks relative to the shapes in front of you and adding textures all help to bring these soft and organic shapes together. Each is different in its own way, but a thread links their natural, biological forms.

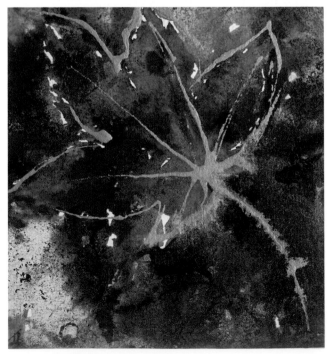

The colours and shapes of objects around us, together with interesting lighting – such as being silhouetted against different backgrounds – can conjure up the most interesting patterns and connections. These patterns are reflected everywhere we look, and provide fantastic inspiration. Being more aware of patterns in organic subjects can be a great source of ideas.

Look at the patterns and colours closely on the things that you like to paint. Look for the textures and designs within them. Don't get it into your head that a leaf is green or the bark of a tree is brown. Look at things with new eyes, it's surprising what you will see: patterns can be found in cracked and dried-out earth; cobblestones and worn-out pathways; gnarled old wooden doors with shabby flaking paint – they are all patterns. Plants often show patterns formed by their branches and twigs intertwining. Similarly the bright jewel-like colours of berries amongst the spiralling, twirly stems of strangling bindweed of other undergrowth all show different patterns and colours.

Everything we look at is a framework of shapes and hues; some of which jump out more than others: dynamic colours like lime greens and turquoises can be seen in the most unexpected places, where they inject a little vibrancy. Lift up some undergrowth or a couple of fallen bits of stone from a wall. You will find some wonderful things happening under there: colours, textures and extraordinary patterns, all made by lichen and moulds.

Once you start looking at subjects in this way, it will reflect in your work. Explore and play with different formats, shapes and configurations; this will encourage you to think in greater depth about how to paint any subject, whether it is organic or not.

All the patterns on the designs shown on these pages are inspired by organic shapes, and made by playing and experimenting, letting the paint flow around different pathways. They are abstract rather than definite subjects, but I really like that approach – it has encouraged me to want to explore abstracts further and could possibly send me down that route with my art in the future.

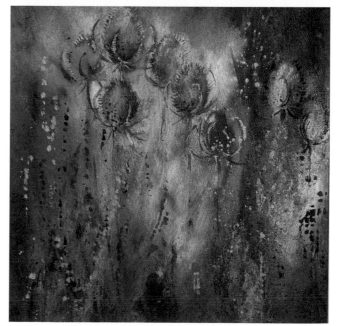

Hard organic forms

Texture links these organic surfaces together. Tree bark, mosaic-like lichen and intricate teasel heads are so diverse to look at, but are united in the richness of their intricate patterns which inspire and rouse my interest. The shared patterns and colours help to motivate me to explore these in any way I can, while trying out various painting methods.

YOUR STARTING POINT

Here we are, at the end of the book, near the top of the creative ladder – I'm leaving the last few rungs to you. I hope you will try some of my ideas, and elaborate on them to take them up another rung in your own work, with new ideas spun off from what you have learnt along the way. However, I hope that you never reach the final rung, as that would mean you have reached the limits of what you can do.

The end of this book is therefore also a starting point. There are a lot of exciting times ahead that will see me exploring and investigating, prodding and poking about in order to find interesting ways to take my watercolours further. I hope this book has helped show that the same is true for you, too.

Just paint!

You may have read through to this point in the book without lifting up a paintbrush, or you may have had a go at some projects already. However you have got here, don't be dismayed if some of your initial efforts don't, or haven't, worked out as you wanted them to. Keep these first ones and keep trying, and you will soon see how much progress you are making.

It is natural to start with the techniques that appeal to you, but please do give the ones that don't appeal so much a try, too – I think you will be pleasantly surprised by the results.

Teasel Textures

Unusual hues alongside more natural colours provide contrast and enhance the intricate teasel shapes. I have incorporated textural markings and gold in this painting.